MANGAWORKSHOP
Characters

How to Draw and Color Faces and Figures

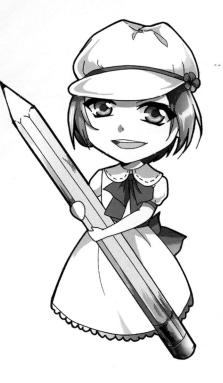

SOPHIE-CHAN

IMPACT
CINCINNATI, OHIO
www.impact-books.com

CONTENTS

1 HEADS 10

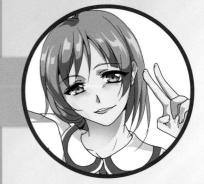

2 BODIES 46

3 COLORING 78

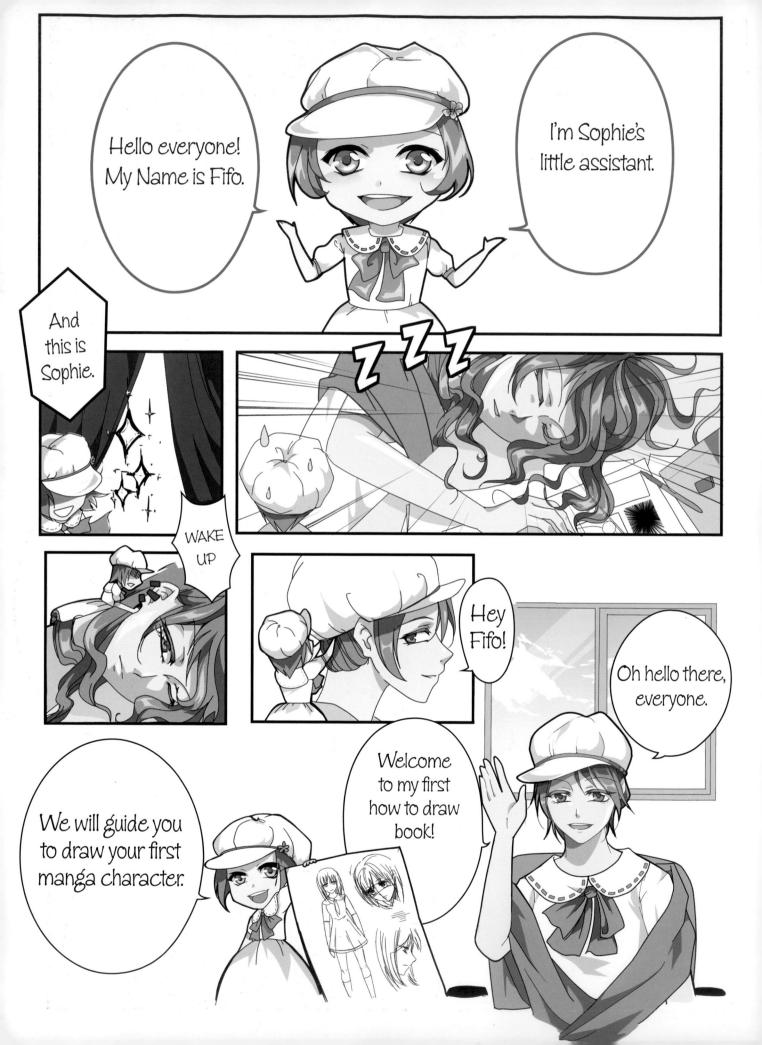

A MESSAGE TO MY READERS

If you know me, you know how much I have struggled to follow my dream of becoming a manga artist. I never studied art (in fact, I have a bachelor's degree in engineering), but I had enough passion to help overcome all the obstacles I faced. I've worked as an engineer by day and a manga artist by night. Truth is, I didn't mind having a day job, as long as I could come home and draw. I grew tired of not being able to pursue art as a career, at first, but now look where I am. Regardless of how hard things get, or how busy you become, if you keep drawing, this hobby will turn into something big that you can actually earn money from and fulfill your potential.

Believe in yourself and create a heartwarming story that you can fall in love with. Don't blame yourself for not having a natural talent for making manga, because those with talent may have no passion and those with passion can become more skillful. It is not mandatory to study art, but I would've progressed faster if I had. If you are given the chance to pursue study in art or animation, then do it!

I wouldn't have reached this far without the support of my fans; having a fan base can boost your energy to work hard. And when you become admired, the last thing you want to do is give up. When I uploaded my first video on YouTube in 2008, I never dreamed of reaching over 20 million video views; it is one more source of inspiration. Accept opinions and criticism; they will help improve your work and open your eyes to flaws you haven't seen in your art. Yet, be your own judge! Don't let negativity influence you—you know when your art is good and can tell when it's not, and this ability strengthens as your artistic experience grows.

Finally, use your work as a message to spread good and peace in this world.

Regards,

Sophie

THE PROCESS OF CREATING A MANGA

Let's begin with an overview of how I create manga from start to finish. We will do this with full details in the last chapter, but for now I want you to keep these general steps in mind.

1) Come up with an idea.

Every manga starts with an idea, a story you would like to share and find worth working on. It can be a personal experience, or a vision, or a message you are trying to spread. The more time you spend writing your story, the greater the chance of completing it. That's why short stories are not ideal for manga. Find what inspires you; for me it was the ocean, which is why I named my manga *The Ocean of Secrets*. Once you come up with an idea, support it by doing some research. Discover if someone has already done a similar story, and try to stay away from stories or themes that are widely used. Be unique and original.

2) Write out the story.

Write down all of your story in dialogues, even if it takes you months. Come up with characters and describe their personalities, even their blood types. When writing events, stick to the personalities you have written for each. My story changed a lot since I started it five years ago; I kept improving it with time. I continued writing five more volumes while the first one was still in progress. I'm truly glad that I didn't jump ahead and publish it too soon, because as I grew older and experienced more, my judgment and understanding of my character's struggles were enhanced. Not to mention, my artwork was not that good back then.

3) Develop character profiles.

I wish someone told me how to make a character profile when I first started. I didn't pay much attention to creating a character profile and ended up with many pages where the same character looked different. The only way to eliminate this mistake is to spend plenty of time creating a detailed character profile that you can follow every time you draw your character.

4) Create the thumbnails or storyboard.

Cut 8½" × 11" (22cm × 28cm) paper in half, and sketch the layout of each page for the entire book. It is important to read the story in order to see if it actually makes sense in terms of transition and events. You can also show it to friends to see if they think it is interesting.

5) Sketch, draw and then ink.

This is the standard work flow of every page. You make a rough sketch first, draw a cleaner version and then ink your drawing. If you are using Manga Studio®, you sketch and then immediately ink, which saves you time. These steps are explained in the Manga Studio® tutorial later in the book.

6) Print it out and solicit feedback.

Assuming you now have finished a chapter or two, it's time to get feedback! If you draw manga purely for fun, you may not need an editor; either show it to your friends or post it online. You will get a lot of feedback, which can help you improve. But If you are taking it to the next level, and you think you can compete with other manga and possibly get published, you'd better have an editor to check your work and proofread it.

7) Don't look back, unless it's miserable.

One problem I became stuck in was going back to redraw the first pages, entering an endless loop of corrections and changes. I redid the first chapter three times, because I have changed my characters and improved throughout the years. Keep in mind that you will keep getting better. It's okay if chapter three is better than chapter one. You will find that the style changes in many of the top manga, and often there is a massive difference between the first and the last volumes.

Keep Moving Forward!

You are constantly improving. There is no need to look back at your older artwork with frustration, because that's what got you here!

Visit **impact-books.com/manga-workshop-characters** to download free bonus materials.

MATERIALS

In this book, I will teach you how to draw and color both traditionally and digitally. The following list of materials contains the very basic supplies you will need, what I personally use, and what I would recommend you use. Find what works best for you; part of being an artist means experimenting with as many tools as you can. If you are a beginner, I recommend you start with traditional art techniques; doing so is not only a lot of fun, it will also train you and broaden your perspective. Once you become more skilled, I suggest you try digital art because it's easier and less time-consuming.

Traditional Mediums

Paper

I recommend bristol paper, which is durable enough to protect your drawing from getting ripped while erasing or inking, and to hold up when coloring with markers.

Ink Pen

There are plenty of manga pens that come in different sizes and are ideal for drawing. I also encourage you to try the manga nib pens (such as the G-Pen); they are challenging to use at first, but the results are outstanding!

Colored Pencils

I'll be demonstrating how to color with basic colored pencils, the kind you probably have been using since primary school. They are affordable and can offer brilliant results.

Copic Markers

I suggest using either Sketch or Ciao brand markers. I'll be demonstrating how to use them. They are somewhat expensive but easy to use. You don't need more than five basic markers to create a masterpiece.

Pencil

A standard pencil is used for sketching. The lightness or darkness of the pencil is up to you. You may also want to use a blue sketch pencil. It's easy to ink over.

Digital Mediums

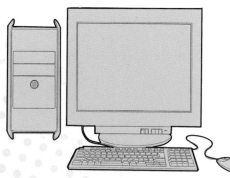

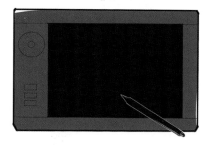

Computer

A reliable fast-processing computer is a must for drawing if you are working on big files (more than 200 dpi).

Pen Tablet

Let's be realistic: It's hard to draw with a mouse! A pen tablet with a pressure-sensitive pen will make digital drawing easier. Quality matters! So save up and buy a good one. Learning how to use one takes time, so don't get frustrated.

Drawing Software

I started with PaintTool SAI (it's amazing with colored illustrations) then spent some time with Adobe Photoshop (it's a joy to color with). I later discovered Manga Studio®, and that's the software I use now. These software programs are not cheap, but they are a onetime purchase—you won't need to buy new pens, papers or colors. So at the end of the day, they are worth it!

TIPS BEFORE YOU BEGIN

Don't compare yourself to anyone. You are uniquely different regardless of being better or worse than other artists. Focus on improving your artwork and treat everyone with respect. Let people see the good in you, and they will love and respect you back.

Practice as much as you can! I don't like to call it "practice" because it sounds like a workout or an assignment. It is basically "drawing." The more you draw, the faster you progress and become better.

Believe lies when they are well-meaning. When I was thirteen, I posted my drawings in online forums and received really nice comments. Looking back at those early attempts, I realize they were awful but people still supported and encouraged me to draw. Believing their lies motivated me to work harder. Thank you to the strangers who said that I had an undeniable talent when my work was really bad. Keep my experience in mind and don't be too harsh on yourself; you are still impressing others with your effort and that means you are on the right track.

Ask questions and learn from everyone. Watch, read and study all sorts of tutorials. It will sharpen your skills, and it's fun to learn new techniques.

Embrace how self-teaching works. In traditional art, buy as many different materials as you can to experiment. In digital art, just keep clicking on things. That's how I learned. It's not a perfect way, but that's how you build your experience and learn.

Enter art contests! Competitions encourage you to challenge yourself, have fun and make new friends. I made the character on this page for the Shonen Jump contest. Kaito was a poor boy who mistreated an old woman and was living with her curse in his unconscious mind after being in a coma due to a train accident.

Learn to accept failure. A publisher may decline, your art may become the subject of a hate thread, and you might lose contests, but every failure will make you stronger and wiser. Learn the reasons why these things happened. Is it bad luck? Or maybe you weren't quite ready.

Part 1
Heads

We'll start by learning how to draw manga heads, faces and facial expressions. We'll study different age groups and designs. You will learn how to draw eyes, noses and mouths as well as different hairstyles. You can use my guidelines to learn how to draw faces, then use your imagination to build your own unique style. This can be achieved by having, for example, your own eye design. Facial expressions are important to master before drawing a manga character, since you have to show emotions and make your characters believable. So grab a pencil and let's get started!

Child Head Front

As a manga artist, you must be able to draw people of all ages. You may have to draw a child when referring to your character's past, for example. Just as in reality, the younger a person is, the larger the eyes, the chubbier the face and the cuter the overall look. In this demonstration, we will learn how to draw a cute little boy in the manga style. If you intended to draw a little girl, then the only major attribute to change is the hairstyle. You may also need to add more eyelashes to emphasize a feminine look.

1 KNOW YOUR GUIDELINES

Start by drawing a circle. Then divide the circle in half with a vertical line. The vertical line establishes the symmetry of the face and will help you draw the eyes within a correct distance from each other. Draw one horizontal line at the bottom of the circle and call it the "nose line." Add another line below that and call it the "chin line."

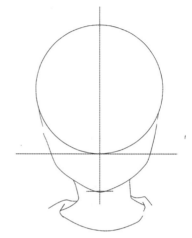

2 SKETCH THE JAW AND NECK

Begin outlining the jaw by drawing a curved line starting from each side of the circle to the chin line drawn in step 1, making sure that the angle used is the same to obtain a symmetrical look. Remember that children in manga tend to have a big head with chubby cheeks.

Sketch the neck, using the vertical line as a guide. The neck's size depends on the body size, which will be discussed in the later chapters.

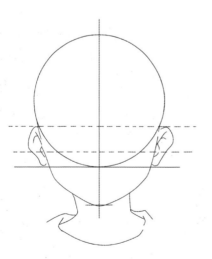

3 DRAW EYE GUIDELINES AND EARS

Draw two horizontal lines that will guide you in drawing the eyes. These two lines (shown dotted) will help you maintain eye proportions. If you are interested in drawing smaller eyes, then reduce the spacing by moving the lower eye guideline up. To draw the ears, draw curved lines from the upper eye guideline to the nose line.

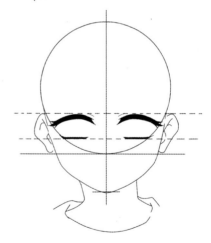

4 DRAW EYELASHES

Start by sketching the eyelid line below the upper eye guideline and then draw the upper eyelashes an equal distance from the nose line. Sketch the lower eyelashes up until the circle. If you have followed the steps carefully, you will see that the eyes fall perfectly within the head circle. This method will help you achieve the symmetrical look you want.

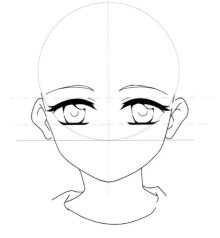

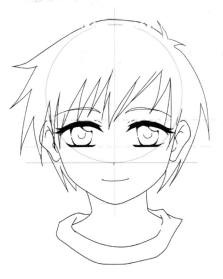

5 DRAW THE EYES

Draw the pupil first and then the iris as indicated. Add a light circle (or highlight) on each eye, following the direction of the light shining on them. Then sketch the eyebrows of your character. Usually manga boys have thick eyebrows, but since this is a child, a thin eyebrow will contribute to a cuter look. The guidelines are blue to avoid confusion.

6 ADD THE NOSE, MOUTH AND HAIR

Sketch a dot on the nose line that you have drawn. Look closely in the illustration above. It's tiny. Can a nose get any simpler than that? Then draw the mouth within the area between the nose line and the chin line.

Sketch the little boy's hair. Hair is not easy to draw but becomes easier as you practice. The key element to remember when studying hair is how to draw smooth strands. Once you can do that, you can draw any hairstyle you can think up. In this demo, I used a very basic hairstyle.

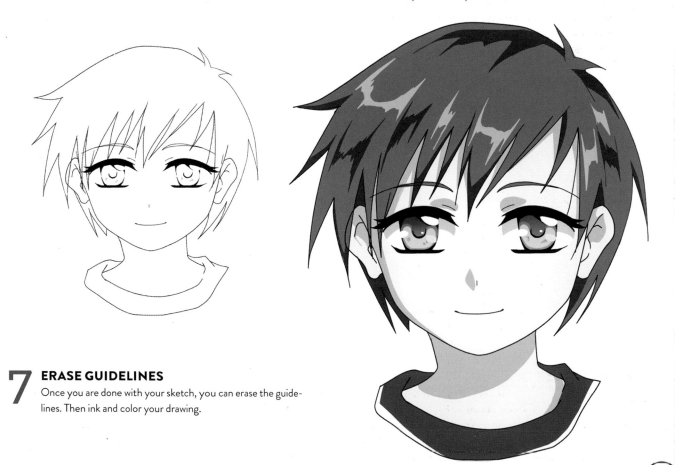

7 ERASE GUIDELINES

Once you are done with your sketch, you can erase the guidelines. Then ink and color your drawing.

Visit **impact-books.com/manga-workshop-characters** to download free bonus materials.

13

Female Head Front

There are numerous styles that you can follow when learning how to draw manga, but eventually you will discover your own—that's the beauty of drawing manga. You learn all the possible styles but find yourself creating your own combination that will identify you as an artist and distinguish you from others. In this demonstration, I will teach you how to draw a teenage manga girl: pretty, funny and outgoing.

1 KNOW YOUR GUIDELINES

Draw a circle (not as big as the one you drew for a small child's head) and then divide the circle in half with a vertical line. Then draw one horizontal line at the bottom of the circle for the "nose line." Add another line below for the "chin line."

2 SKETCH THE HEAD

Start outlining the head shape following the guidelines you have drawn in step 1. Make sure that the face's bone structure is symmetrical and that one side is not chubbier than the other. Draw the neck of your character, trying to balance it with the head size.

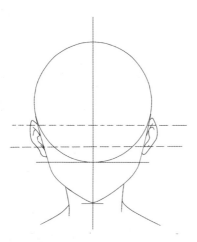

3 DRAW EYE GUIDELINES AND EARS

Sketch two horizontal lines to be your guide when drawing the eyes. Use those guidelines to help draw the ears. Most of the ear will fall between the two lines. The ears may reach the nose line in some cases if they're really long.

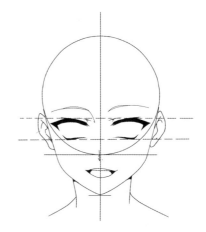

4 DRAW THE EYELASHES, NOSE AND MOUTH

Draw both the upper and lower eyelashes within the guidelines you have drawn in the previous step.

Draw the nose (just a small vertical line is good) on the nose line, and sketch your character's mouth as shown. The nose location is fixed, but the mouth can be anywhere underneath, depending on the expression you are trying to convey.

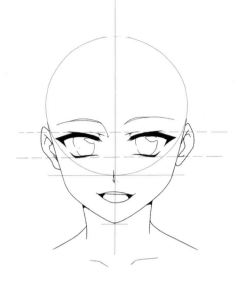

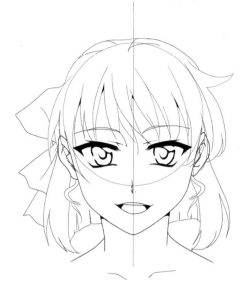

5 DRAW THE EYES

Draw circles (which will contain the iris and pupil) in the eyes of your character. Make sure that the circle highlight is in the direction of the light, an important concept to remember when shading.

6 FINISH THE EYES AND DRAW THE HAIR

Outline the iris with a thicker line along with the pupil; this gives more definition to the eyes. Then sketch and outline your character's hair. The hair here is not as complex as it seems and will be explained in later chapters. For now, practice drawing smooth strands; once you master that skill, you can draw any desired hairstyle.

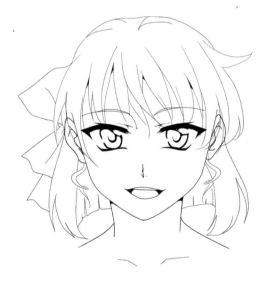

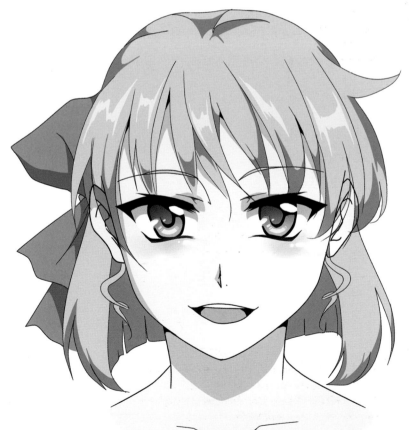

7 ERASE GUIDELINES

Once you are done with your sketch, erase the guidelines. Then ink and color your drawing.

Visit **impact-books.com/manga-workshop-characters** to download free bonus materials.

15

Female Head Side

Just as you find different face styles in manga, you will also encounter different profile designs. In some manga, the features are very sharp and edgy, while in others they are very unrealistic and small. In this demo, I'll focus on the least complicated form of profile designs.

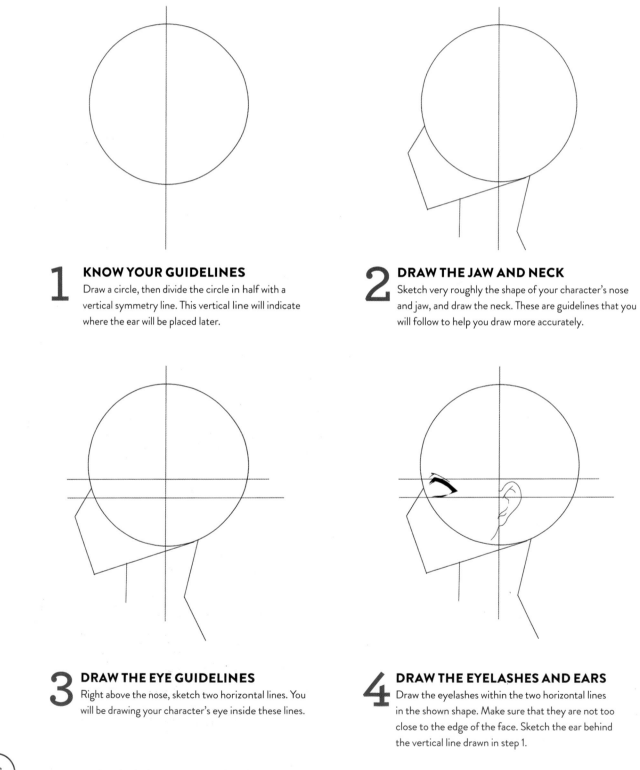

1 KNOW YOUR GUIDELINES
Draw a circle, then divide the circle in half with a vertical symmetry line. This vertical line will indicate where the ear will be placed later.

2 DRAW THE JAW AND NECK
Sketch very roughly the shape of your character's nose and jaw, and draw the neck. These are guidelines that you will follow to help you draw more accurately.

3 DRAW THE EYE GUIDELINES
Right above the nose, sketch two horizontal lines. You will be drawing your character's eye inside these lines.

4 DRAW THE EYELASHES AND EARS
Draw the eyelashes within the two horizontal lines in the shown shape. Make sure that they are not too close to the edge of the face. Sketch the ear behind the vertical line drawn in step 1.

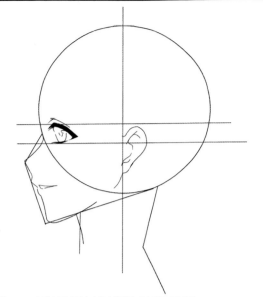

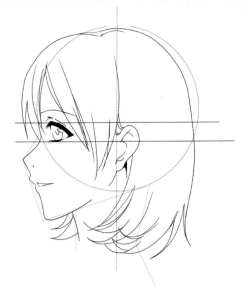

5 DRAW THE MOUTH AND EYE

By using the nose/jaw shape as an outline, draw the face profile of your female character. Pay attention to where you place the mouth; it must always be lower than the ears. Draw the eye's pupil and iris at a tilted angle. In some cases, the iris is very narrow to give a better feel for where the character is looking.

6 DRAW THE HAIR

Sketch the character's hair, following the initial guidelines you set when drawing the head. The hair shouldn't go beyond that circle (except for the length) or the character will look out of proportion. In some cases, you may need to readjust it, as you will see in the next demo.

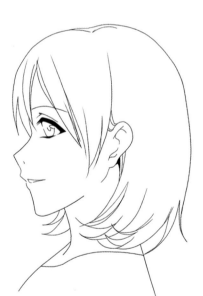

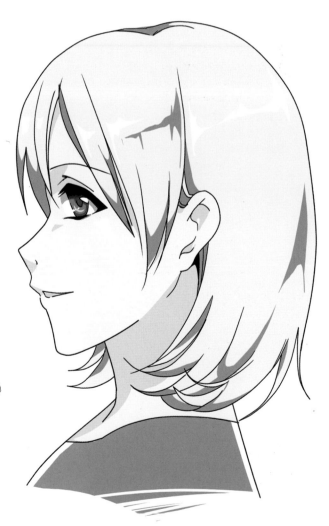

7 ERASE GUIDELINES

Once you are done with your sketch, erase the guidelines. Then ink and color your drawing.

Visit **impact-books.com/manga-workshop-characters** to download free bonus materials.

17

Male Head Front

It is important to recognizé the differences between male and female characters. Some features do overlap in the manga style, yet certain rules are established to differentiate between the two. For example, male characters have smaller eyes and wider necks. The age of the character can affect how masculine you want the character to be. Young boys have a small, less edgy face with big eyes, while older males have narrower eyes. It all depends on how you want to convey your character and what best suits his personality.

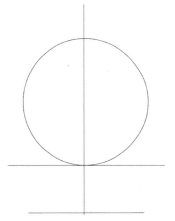

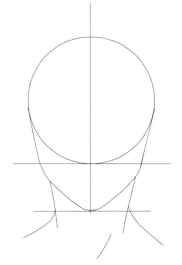

1 KNOW YOUR GUIDELINES

Start by drawing a circle, then add a vertical line to divide the face (the symmetry line). Then draw one horizontal nose line at the bottom of the circle and add another jaw line below it. The larger the distance between the two lines, the longer and edgier the face.

2 SKETCH THE HEAD

Sketch the jaw, chin and neck. Usually the chin is not as pointy as the female character's, unless your male character is a young boy. Pay attention to the size of the neck, which portrays a masculine look.

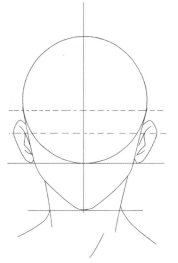

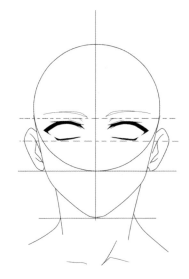

3 DRAW THE EYE GUIDELINES AND EARS

Draw two horizontal lines to be your guide when drawing the eyes. Sketch the ears as shown. A good approach is to place the bottom of the ears on the nose line.

4 DRAW THE EYELASHES

Draw the upper and lower eyelashes in the drawn guidelines. Draw the eyebrows above the upper eye line. Usually thicker eyebrows indicate a more masculine, strong and mature character while the opposite applies for thin eyebrows (it is not a rule, but it's a common belief).

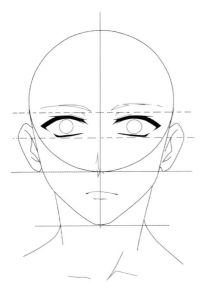

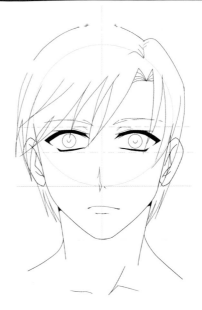

5 DRAW THE EYES, NOSE AND MOUTH

Draw the iris of the eyes in the center of the eye. As I mentioned, small eyes are better suited for male characters. This circle eye style makes the eyes appear smaller. Sketch the nose in the nose line. Male noses are somewhat longer than female noses. Then sketch the mouth and define it with a lower lip line.

6 DRAW HAIR

Draw your character's hairstyle. You may notice that I have gone a little beyond the head circle guide; you may make such adjustments if you find that your face lacks in proportion. This skill of readjustment will come naturally to you with practice, which gives you a good eye to judge and improve your drawings.

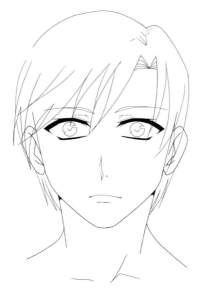

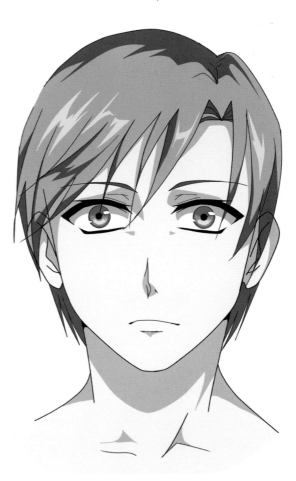

7 ERASE GUIDELINES

Once you are done with your sketch, erase the guidelines. Then ink and color your drawing.

Visit **impact-books.com/manga-workshop-characters** to download free bonus materials.

19

Male Head Side

Since male manga characters have more prominent bone structure, their side view should emphasize that profile. This demo is similar to the female profile; it is very basic, and I find this style very beautiful. The key is to learn how different styles are drawn and then come up with your own unique inventions. If you are still a beginner, then this is your chance to experiment with my style.

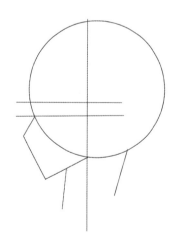

Don't Forget Profile Views

It is crucial to create a profile design of every character you use in your manga. You'll be glad you have the reference!

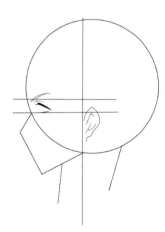

1 KNOW YOUR GUIDELINES

Draw a circle, then add a vertical line closer to the left side of the circle. The left portion of the circle will include the face profile, and the right side will include the ears and most of the hair.

2 SKETCH THE PROFILE

Sketch the face profile by drawing the lines shown. Also roughly sketch the character's neck. These guidelines will help you when drawing the face profile view.

3 EYE GUIDELINES

Draw two horizontal lines for the eye; you don't need to extend the lines all the way across the circle. Make sure the distance between the two lines is realistic. Male characters have smaller eyes than female characters.

4 DRAW THE EYE AND EAR

Draw the eye's upper and lower eyelashes. Make sure that the eye is within the two horizontal guidelines. Sketch the eyebrow and ear in their respective locations.

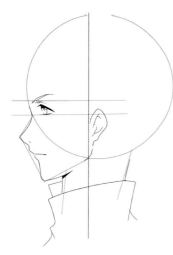

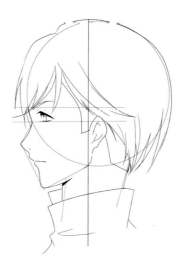

5 DEFINE THE PROFILE

Go ahead and place the nose and mouth following the guideline drawn in step 2. Pay attention to the angle of the jaw and how edgy his side view appears to be.

6 SKETCH THE HAIR

Follow the circle guideline to draw the hair. Having a front view reference of your character will make it easier.

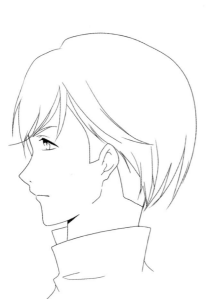

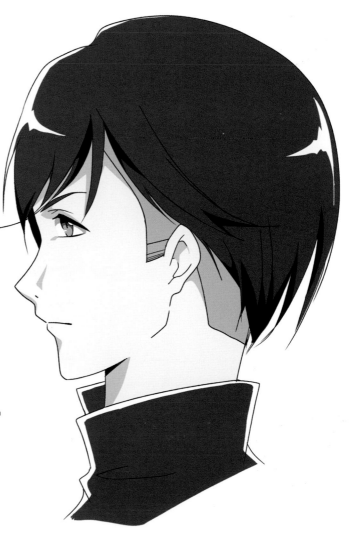

7 ERASE GUIDELINES

Once you are done with your sketch, erase the guidelines. Then ink and color your drawing.

Visit **impact-books.com/manga-workshop-characters** to download free bonus materials.

21

Old Man Head Front

Chances are, if you are serious about writing a long manga story, you will need to draw some older people. The best way to prepare is to observe old people and how their faces and features are defined: how the wrinkles are laid out and how their eyes are shaped. In this demo, you will be drawing a serious, strong old man who looks like a kendo master.

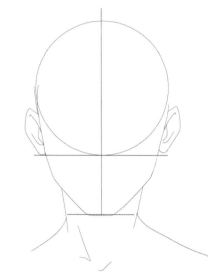

1 GUIDELINES FIRST

Draw a circle, then divide it in half with a vertical line. Then draw a horizontal guideline at the bottom of the circle (we'll call it the center line). Another line is needed below that, which is the chin line. The same approach is used for all front view heads, the only difference is the distance between the two horizontal lines. The larger the distance, the more masculine, edgy and old the face is.

2 SKETCH THE HEAD

Sketch the jawline and chin, and draw the neck. The vertical line you have drawn becomes handy when sketching the jaw. It helps you to achieve a symmetrical face. Pay attention to the chin. The wider it is, the older your character is. Sketch the ears closer to the ends of the center line.

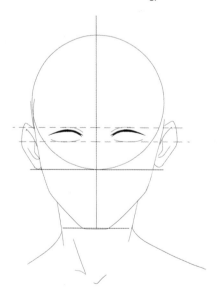

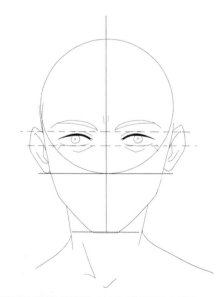

3 SKETCH THE EYES

Draw two horizontal guidelines that will aid you when drawing the eyes. Because old people tend to have small and narrow eyes, draw these lines close to each other. Then draw the eyelid and the upper and lower eyelashes.

4 DEFINE THE EYES AND EYEBROWS

Draw a small iris and pupil in the eyes. Add wrinkles below the eyes, and also around the eyes and above the forehead. Add thick eyebrows to the face.

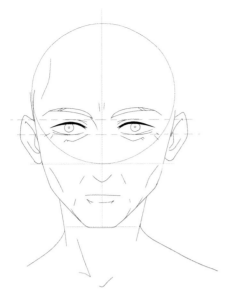

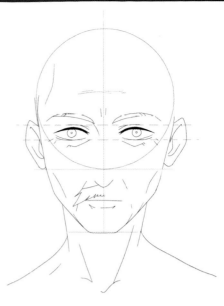

5 ADD FACIAL FEATURES

The nose in this method will be drawn differently to highlight a long and more realistic nose. Draw the nose under the center line of the face. Then draw the mouth with a defined lower lip line. Draw two wrinkles around the mouth to emphasize aging. Also add lines around the forehead, and the cheekbone lines, which also indicate aging.

6 ADD CHARACTER DETAILS

Add one side of the moustache as shown, drawing from the center line, and sketch the lines in the neck. Add more lines to the forehead. The more lines you add, the more realistic your character will look. In manga, if your style isn't too detailed, these lines are enough.

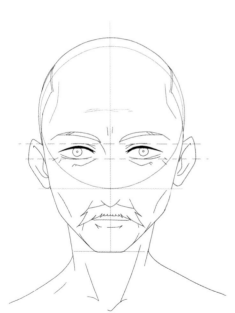

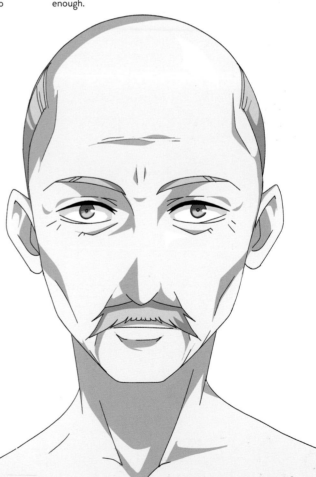

7 FINAL DETAILS

Add the other half of the moustache, keeping the shape symmetrical to the first half and you are now done drawing your kendo sensei! Erase the guidelines and add color to finish the piece. Muted tones are good for older people.

Visit **impact-books.com/manga-workshop-characters** to download free bonus materials.

23

Drawing Male Eyes

While there are numerous ways to draw a manga eye, there are established differences between female and male eyes. Male eyes are generally smaller with fewer sparkles and eyelashes. The eyes can tell a lot about the characters; for example, the sharper and smaller the eyes, the more serious or old your character is. The following demo will focus on how to draw an adult male's eyes.

1 GUIDELINES FIRST
Draw two parallel horizontal lines and one vertical line exactly on the center. You will be drawing the eyes inside the two rectangular guides you have drawn. The vertical line establishes the symmetry of the face and will help you draw the eyes within a correct distance from each other.

2 EYELIDS
Start off by drawing the eyelid. Keep each the same distance from the symmetry line. This demo is a front view; therefore, the eyes must be identical in size.

3 EYELASHES
Draw the upper and lower eyelashes within the horizontal lines. To ensure that they look the same, I highly recommend using a ruler if you are a beginner. Use equal spacing for each eye from the symmetry line. You may also use grid paper, if you are in the process of sketching, or virtual guides if using a digital medium.

Eyelash Thickness
You may vary the thickness of the eyelashes, but don't make them too thick on males or they might be mistaken for females. Remember that male characters have thin eyelashes.

Simple

Another simple mouth style,
used mainly for male characters.

Shouting

This is an example of shouting, with
the teeth shown.

Speaking

One of my favorites, this can be used when
the character is talking.

A Little Lip

Another style used primarily for male characters.
It emphasizes the lip's shape, which makes the
character more realistic.

DRAWING EARS

Ears are important when drawing heads. You can't always guarantee that your character's ears are covered by hair. These examples will show you the differences between real and manga ears, and how the ear looks from different views. You will also learn how to draw cat and elf ears, which are common in fantasy-themed manga series.

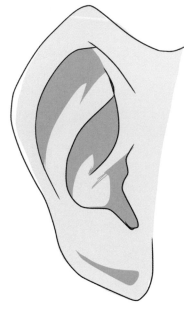

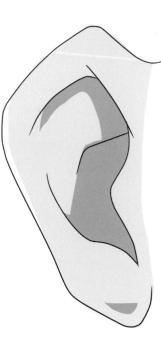

Realistic vs. Manga
The difference between realistic and manga ears is shown here. Realistic ears have more curves and lines, unlike the manga ears which are simplified into a few lines with fewer curves.

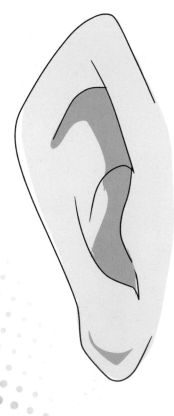

Front View
In this front view of a manga ear, the ear appears narrower than in the side view shown above.

Back View
This back view of a manga ear is not common but you may experience situations in which it is needed.

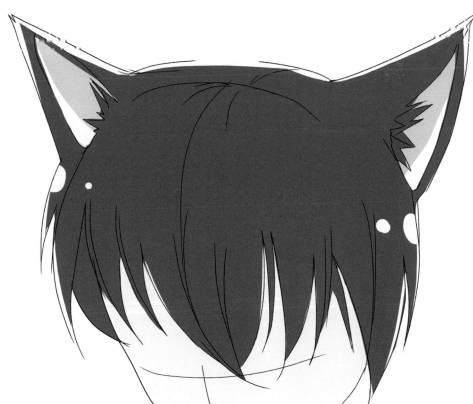

Cat Ears

The color of these cat ears are similar to the character's hair. The ears' interior tends to be pink in color.

Elf Ears

Elves are supernatural characters found in fantasy manga series and video games. This is how their ears are drawn in case you ever need to draw one. The ends are elongated and pointed.

Visit **impact-books.com/manga-workshop-characters** to download free bonus materials.

35

FEMALE HAIRSTYLES

This section covers different hairstyles that you may want to use when designing female manga characters. I have divided each into two steps: the first is a sketch, the second is an actual outline. You may use a light colored pencil for the sketch, draw the outline in ink and then erase the sketch. The most important aspect of drawing the hair is drawing the smooth hair strands. This comes with practice; once you've practiced the basics, you can draw any hairstyle you prefer.

Simple Hair

Let's start with this simple hairstyle. Begin by sketching the big hair strands, then start outlining as shown with curved lines. The more curved your lines are, the more realistic your character is going to look.

Childish Hair

Here is a more childish hairstyle. Sketch the hair design as shown and then start outlining. The more lines you add, the better, but don't overdo it!

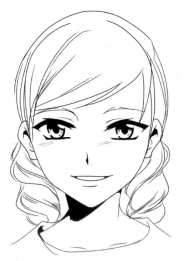

Curly Hair

Let's look at some curly hair. Start sketching the hair very roughly. Then with a fine pen, add lines to show the curls. This style is used to emphasize gentle, kindhearted manga girls.

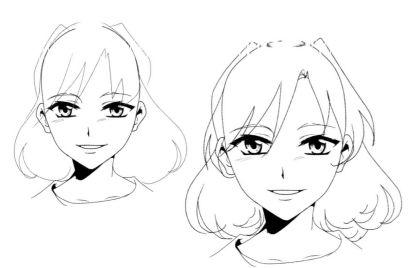

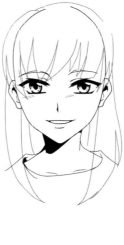

Dramatic Hair

Let's try a more dramatic hairstyle. Start by roughly sketching your lines. Then outline the hair by following the lines you have sketched. The sketch acts as a guideline that will help you place your lines within a realistic distance to the head.

Straight Hair

This straight hairstyle is very common in manga. Start sketching thick strands first to outline the shape and the length of the hair. Then use a pen to draw smaller hair strands.

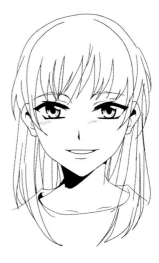

Hair Complexity

The more complex your characters' hairstyles are, the more time you need to draw your manga, so balance their looks to match your drawing speed.

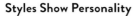

Styles Show Personality

The hairstyles you come up with depend on your character's personality. These are examples of more complex hairstyles.

37

MALE HAIRSTYLES

Hairstyles can suggest many things about your male characters. For example, fighters in action manga tend to have messy hair with more volume. In school life/drama series, boys tend to have straighter/longer hair. It depends on the setting of your manga and the personality of each character. Another common belief is that the longer the hair, the stronger the character.

Wild Small Strands

Start by sketching the strands around the head, then use your pen to outline the strands as shown. This style with many flying hair strands is seen in action manga, usually used for main characters.

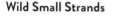

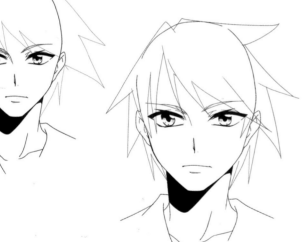

Wild Big Strands

This style is used in fantasy manga series. It is unrealistic to see this style in school life genres. Start by sketching the strands longer on one side, then outline them as shown. The strands here are bigger than the first hairstyle.

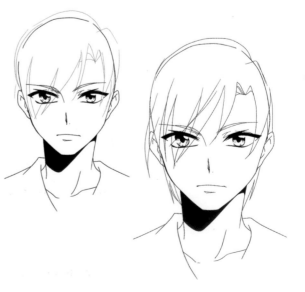

Smooth Hair

Let's look at a much calmer hairstyle. This style is seen in drama and romance manga series. Sketch the hair design first, then outline the strands. You can add more strands for a more realistic look.

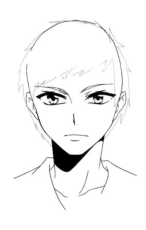

Sporty Hair

This style is common in sports-themed manga series. It is simple yet realistic and can be a good option.

Hair Reveals Personality

Here are three different hairstyles for male characters. The first hairstyle is basic hair that may work for a hero character. The second is the main character's kind friend who's always there. The third hairstyle is for either a villain or a vampire. The personality of the character determines the hairstyle.

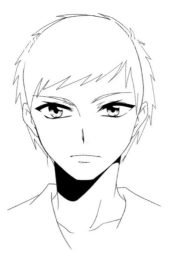

Hair Design

It is important to have distinctive hairstyles for your characters. You don't want your readers to get confused when reading your manga!

Visit **impact-books.com/manga-workshop-characters** to download free bonus materials.

Different Head Angles

It is essential that you learn how to draw characters with different head angles, especially if you are creating a manga. Creating a manga is similar to directing a movie: The characters are not always viewed from the front or the side, and viewers will become very bored if that is the case. The key to mastering this skill is knowing your guidelines and how to use them to draw the same character in all angles.

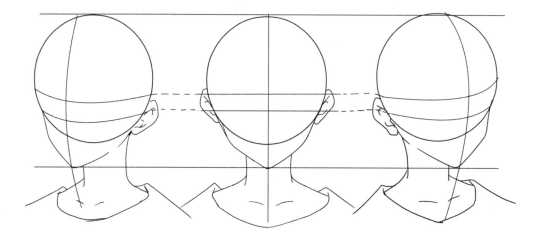

1 KNOW YOUR GUIDELINES

For a given character in front view, sketch the corresponding guidelines. We have already studied the front view guidelines in previous demos. The idea here is placing these guidelines in the same level and extending them to the three-quarter view (where we see all but one-quarter of the face). This way will maximize your chance of getting similar faces in different views.

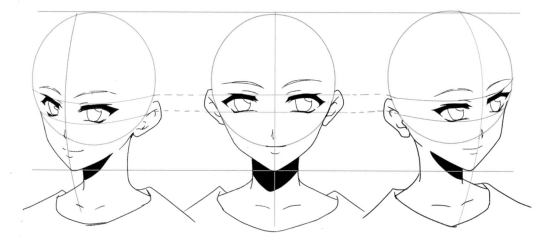

2 SKETCH THE FACE

Sketch the eyes in their correct space between the two horizontal guidelines. The nose must lie on the center line. The eyes become tricky with different angles but the more you practice this method, the faster you acquire the skills. The eye on the far side emphasizes the head's angle, which helps to portray distance. The shadow on the neck changes depending on the light source and the angle of the head.

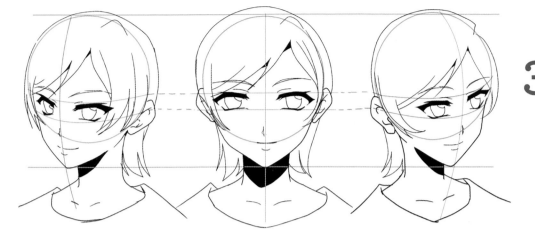

3 SKETCH THE HAIR

It is best to start with the front hair and then try to visualize the change as you turn your character's head. You may also get references from real-life models and observe how their hair changes when the angle changes.

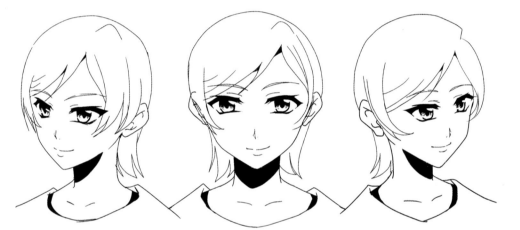

4 ADD DETAILS

Erase the guidelines you have drawn, and develop the eyes of your character. Then ask yourself if the three-quarter view resembles the same character. If yes, you have finished a crucial part of your character profile. If it still looks off, try to simplify the eyes or hair to get a closer resemblance.

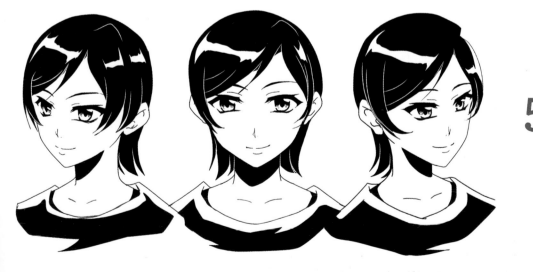

5 ADD SHADING

You may apply shading or color your design. In a character profile, you usually leave it in black and white with just the front view in color, but there is no hard rule when it comes to coloring.

Visit **impact-books.com/manga-workshop-characters** to download free bonus materials.

41

FACIAL EXPRESSIONS

Expressions are as important as character design. You need to master the use of each expression to tell your story. The use of these expressions can vary from one artist to the other, but they all come from the understanding of human nature. Let's review a few of the expressions that you will encounter when drawing your manga.

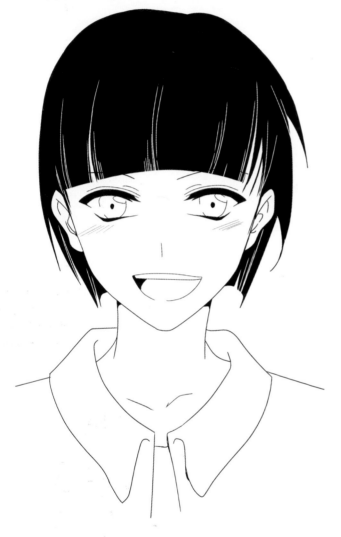

Happy

You can see how the eye size expands when a character is happy. The blush lines show enthusiasm. You may also add more than one light reflection to the eyes to give a sparkly effect. This expression is used when a character is either happy or excited.

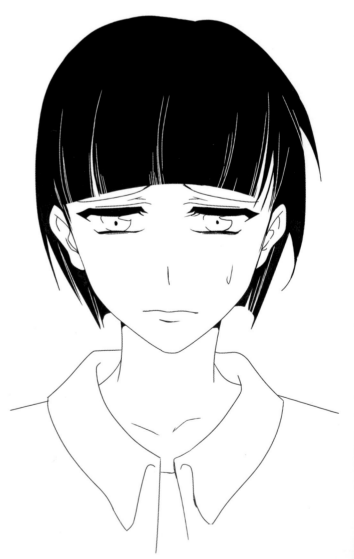

Sad

This expression is used when the character is down, concerned or worried. Note that the eyes are not fully open, giving the impression of looking down. The drop on the side represents sweat, which is seen when someone is worried, stressed or disappointed.

Crying

You will surely encounter this expression if you are drawing a full-length manga story. The tears show how sad and hurt your character is. The largely spaced lines for the blushing indicate that the character's face is turning red. She is biting her lip, which indicates regret and adds to the overall expression.

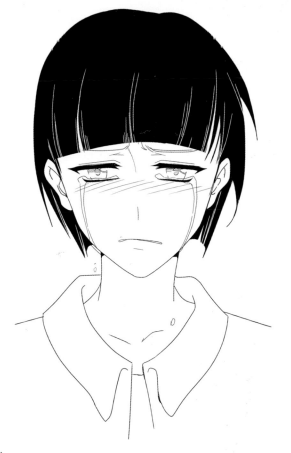

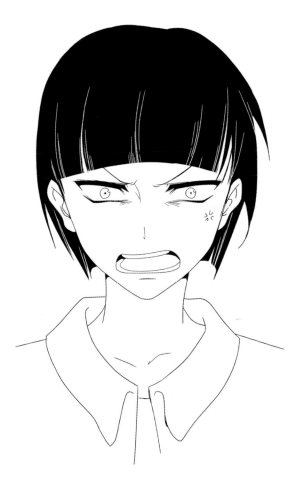

Angry

This expression is used when the character is annoyed, upset or bothered by something. Note the eyebrow's shape and how important that shape is to define this look. The eyeballs become really small, which adds the look of surprise. The mouth is open, indicating the tone in which the character is speaking—in other words, screaming!

Confused

This expression portrays a scared/confused state of mind. All the tiny sweat drops indicate discomfort and nervousness. The lines under her eyes and the shadow above her nose add to the effect. The eyebrow's shape can also indicate confusion and contributes to the overall look.

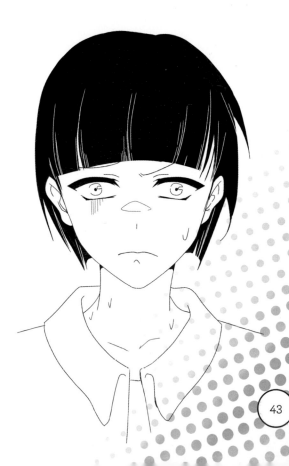

SHADING

Shading your characters can enhance the overall look of your manga page and can provide hints concerning the time and environment in which your story takes place. For example, are these events taking place at night (in which heavy shading is needed) or during a sunny day (where light shading is needed)? Shading can also convey dark colors; for example, a shaded hair may indicate a darker hair color than hair with no shading. In this section, we will learn how to shade a character using different light intensities.

First, let's draw a character in front view. We'll use this picture to describe the possible shading patterns.

Low Light

This is an example of low-light shading. I've added minor shading to the hair, eyes and neck. This pattern can be used for sunny days or in rooms with bright light or when you just want lighter shading.

Medium Light

This is a medium light shading that indicates a single source of light coming from the right. This type of shading can help to define the features of your character. It can be used in indoor settings or on nights with a full moon. Make sure that the eye highlights coincide with the direction of light.

Backlight

In this case the light is behind your character. It can be during sunset or when there is not much light in the room. This type of shading may also emphasize shock/sadness or can be used for people in the background. Once again, these are not rules, but conclusions I've come to while drawing manga.

Solid Black Shading

I have used tones from Manga Studio® in the previous examples; in this example I am using ink alone to define the shading. This is a standard method that is part of inking your manga. Instead of using light tone to shade, you are just using black ink. The choice is up to you depending on your preferences. Take some time to experiment.

Shading Hair

Indicating Hair Color

Instead of leaving the hair white, you can add shading to indicate a darker hair color. The darkness of the tone used can vary. A lighter tone may indicate a light brown, while a darker tone can be used for dark brown.

Going Dark

You can use black ink to indicate a character with black hair. This type of hair shading can enhance the overall look of your manga and add more depth to it. You don't have to shade your characters all the time, but when it comes to hair, you have to be consistent from page to page. A character who has black hair on one page and a lighter tone on the second may confuse readers.

Visit **impact-books.com/manga-workshop-characters** to download free bonus materials.

45

Part 2
Bodies

One of the key elements in drawing manga is telling the story. To tell the story, you'll need to draw your characters in different poses and from different angles. This chapter will explain how to draw female and male manga bodies in various poses and clothing designs. Both will help you when you're creating your characters.

Body shapes depend on your style and the kind of story you are writing. For example, detailed body art is used for mysterious or science fiction manga, while less detailed body art with a smaller ratio is used for childish or comedy manga. Smaller head to body ratios are simpler to draw, which is why it is good to start with the 1:5 or 1:6 body ratio before trying other ratios (see next page).

BODY PROPORTIONS

If you are a fan of collecting how-to drawing books, you will probably see a chart like this one every time you open up the body drawing section. Bodies seem complicated, but you won't need to use them all. All you need to know is that typical adults have a 1:8 or 1:7 head-to-body ratio—meaning that if you stack your head eight times to form a vertical line, you would arrive at your height. Then we adjust this standard ratio to proportionally draw different ages and types of characters.

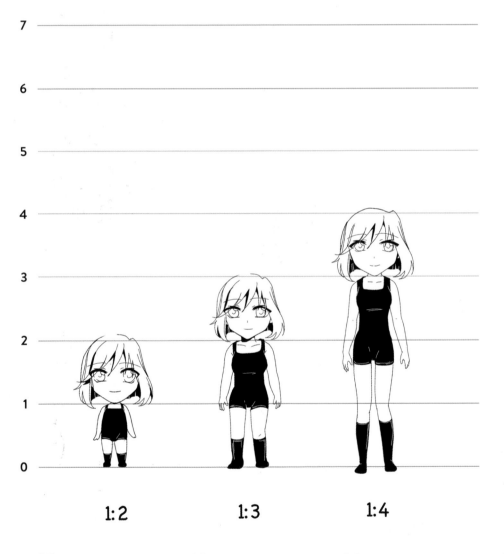

1:2

1:3

1:4

1:2
This ratio creates a chibi (meaning "little child") and is used to describe your characters in humorous situations in manga. The head size is as big as the entire body size.

1:3
This ratio can also be used in manga, for the same purpose as the chibi. This body ratio can also be used for little kids.

1:4
This ratio can be used for school kids. I have preserved the character's adult body shape in this example, but if this was for a kid, her body would have fewer curves.

Detailed Figures

You will need to add more details as you increase the head-to-body ratio! The chibi and child figures are simpler than the adult.

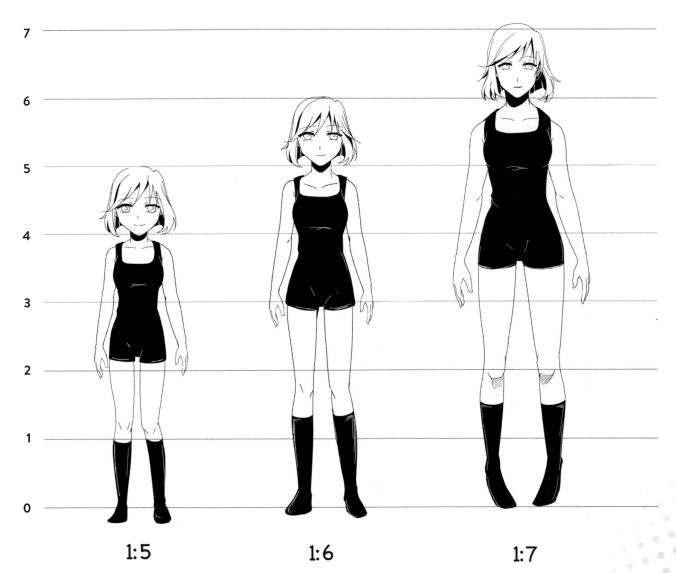

1:5

1:6

1:7

1:5

This ratio is widely used for elementary school students. You might need it if you are referring to your character's past or using young characters in your manga.

1:6

This type can be used for either elementary or secondary school students. You may pick this ratio if you are interested in a simpler look for your characters.

1:7

This ratio is frequently used for high school students and adults. The eyes are smaller and the overall look is more mature.

Drawing a Chibi

Drawing a chibi character is simple and straightforward. I have tried my best to simplify the steps here so that you can apply it. Remember that the more you practice, the easier this becomes and the faster you will get the hang of it. In this demo, we will learn how to draw a schoolgirl in chibi style. So sharpen your pencil and let's start!

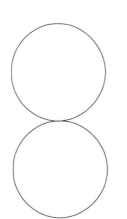

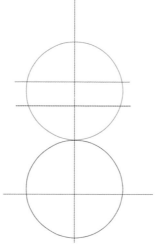

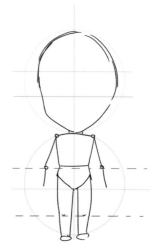

1 DRAW CIRCLES

Draw two circles of the same size. These circles are the body ratio. Remember we said that chibi characters have a 1:2 ratio, which means that the body height is twice the height of the head.

2 ADD GUIDELINES

Divide the circles in half vertically; this will be the character's symmetry line. Draw two horizontal lines in the upper circle (head) for the eye guidelines. Chibis are characterized by big eyes. Then divide the lower circle in half with a horizontal line. The torso is above that line, while the legs are below it.

3 SKETCH THE BODY

Start sketching the body as shown. The shoulders are at the top of the lower circle. The elbows are located in the center of the upper half while the knees are placed in the center of the lower half.

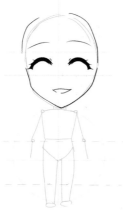

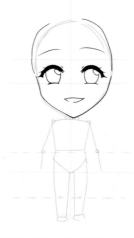

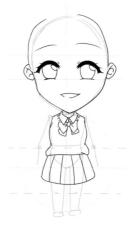

4 START INKING

Start drawing the actual outline. Begin by outlining the head and draw the mouth as shown. Then draw the upper eyelashes as shown. These chibi eyes are going to be big and cute.

5 FINISH THE EYES

Draw the iris and pupil. Then draw the lower eyelashes on the lower horizontal line.

6 DRAW THE UNIFORM

Draw the character's ears, shirt collar and tie. Sketch the shirt and the skirt as shown. This design is a basic school uniform. You can research other uniforms for design variation.

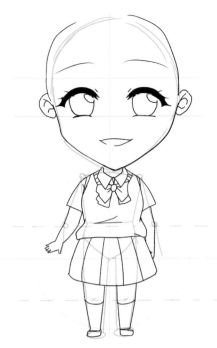

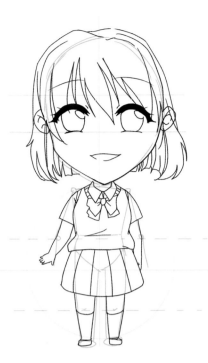

7 DRAW THE ARMS AND LEGS

Following the guidelines sketched, draw the arms and legs of your character. Notice how the arms and legs fall within the second circle guideline. The guide helps you to maintain the correct ratio.

8 FINAL DETAILS

Sketch the hair and add any final details to the uniform that you want (including knee-high socks). Erase the guidelines and you're ready to add color!

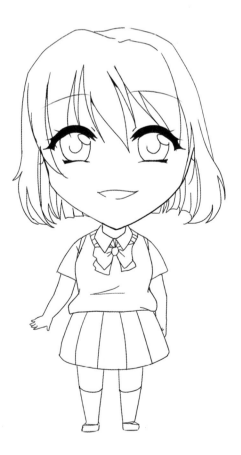

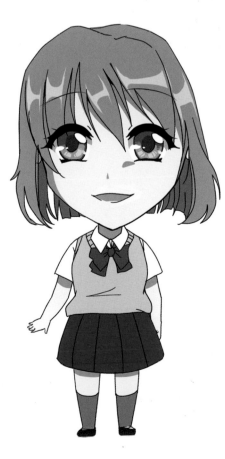

Visit **impact-books.com/manga-workshop-characters** to download free bonus materials.

51

Drawing a Female Adult

We will start with a female 1:7 head-to-body ratio. I will guide you step-by-step to draw this figure. Human anatomy is a massive subject that requires a lot of study and practice to master. As a self-taught artist, I'm still learning.

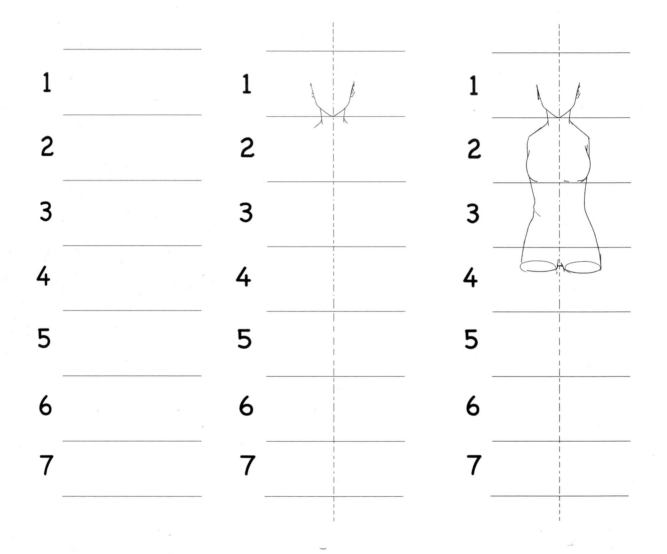

1 DRAW HORIZONTAL GUIDELINES
Draw eight equally spaced horizontal lines with seven regions.

2 ADD VERTICAL GUIDELINE
Draw a vertical line that divides the horizontal lines in half. Draw the head of your character in region 1. Make sure that the chin is placed exactly on the horizontal line and centered on the vertical.

3 ADD THE TORSO
Using the horizontal guidelines you have drawn, remember the following: The breast lies on the third line. The waistline is the midpoint of region 3. The torso ends in the upper part of region 4.

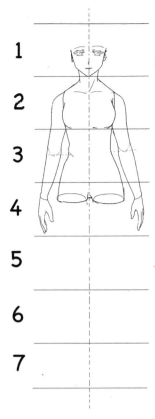

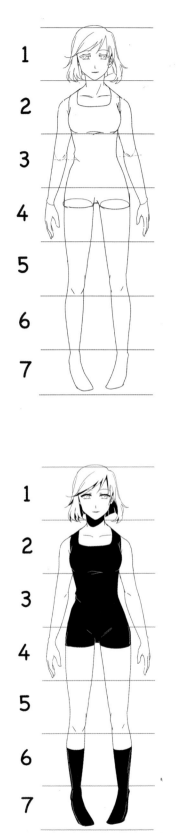

4 ADD ARMS

Start sketching the arms. The elbows are slightly higher than the waistline; for simplicity, they can actually be on the same level as the waistline. The hands should end in region 4. I have sketched the face in this step; you may do the same following guidelines you have used in the previous demos.

5 ADD LEGS

Sketch your character's legs. The knees are in the lower part of region 5. The ankles start in region 7. The thighs are thicker than the calves; this varying thickness makes it challenging to draw. Draw the hair, which shouldn't exceed the top line. The head should occupy all of region 1.

6 FINAL DETAILS

Ink your drawing and draw a few lines in the elbows and knees.

Visit **impact-books.com/manga-workshop-characters** to download free bonus materials.

53

Female Side View

The same head-to-body ratio concept is adapted when drawing a profile view of your female character. The locations of the body parts fall within the same guidelines. When creating a character profile, it's a good idea to draw the front, side and back view all together on one page with the same guidelines. This will minimize errors.

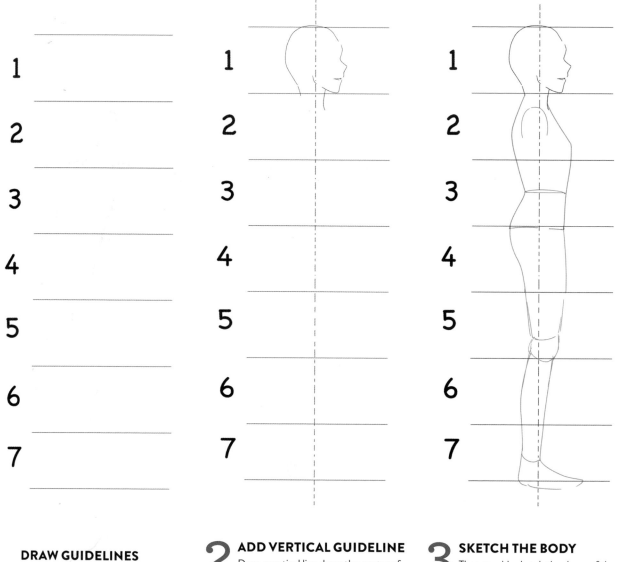

1 **DRAW GUIDELINES**
Draw eight equally spaced horizontal lines with seven regions.

2 **ADD VERTICAL GUIDELINE**
Draw a vertical line down the center of the horizontals. In the first region, draw your character's profile head as you learned in the previous demos.

3 **SKETCH THE BODY**
Then roughly sketch the shape of the body. The breast rests on the third line. The waistline is in the center of region 3 and that's where the elbows will be. The knee ends on the sixth line and the foot ends in region 7.

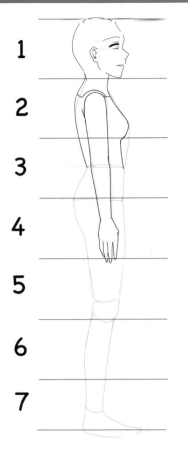

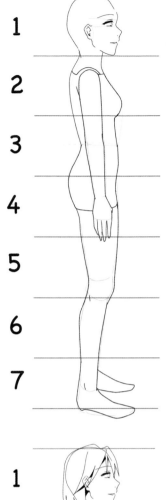

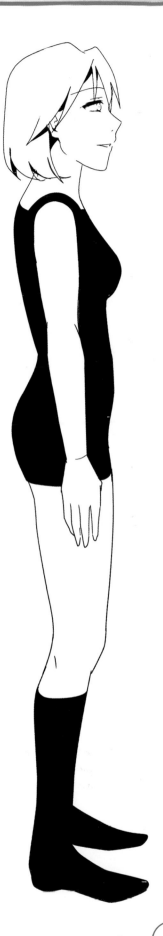

4 ADD INK

Accurately ink the upper body following the sketch you made in the previous step. The hand ends on the fifth line. Follow the guidelines we have set and remember to make the lines as smooth as possible.

5 INK THE LOWER HALF

Ink the lower part of the body, keeping in mind the varying thickness of the thighs and calves.

6 FINAL DETAILS

Draw your character's hair and erase the guidelines. Then apply shading.

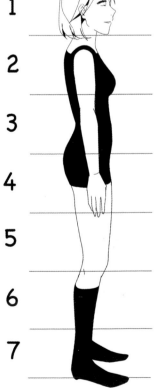

Visit **impact-books.com/manga-workshop-characters** to download free bonus materials.

55

Drawing a Male Adult

In this demo, we will learn how to draw a manga-style male body. The body shape will depend on whether your character is slim or big, short or tall. This demo is for an average young male body design. Once you learn the basics, you can experiment with different body types.

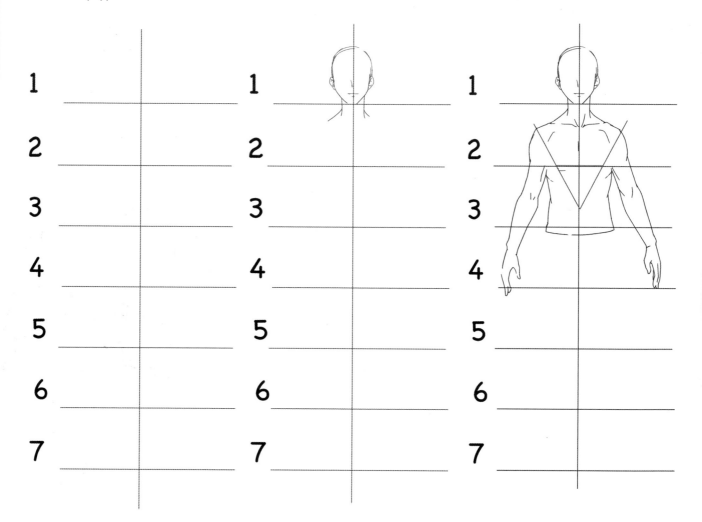

1 DRAW GUIDELINES
Begin by drawing seven equally spaced regions. These will act as a guideline to help you maintain correct proportions. Add a vertical (symmetry) line down the center.

2 SKETCH THE HEAD
Sketch your character's head in the first region. Notice how the chin rests on the end of the first region. You may also draw the ears and neck as shown.

3 DRAW THE TORSO
The center of the third region is where the belly button is; if you extend two lines up diagonally, this is where the shoulders end. Then draw a horizontal line to complete the triangle (which lies on the second line). The intersection of this horizontal line and the two diagonal lines is where the nipples are located. The center of region 3 is the height at which the elbows are and will help achieve a realistic arm.

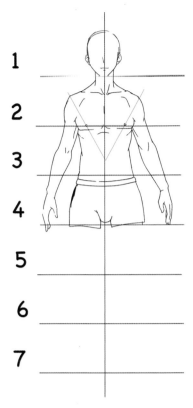

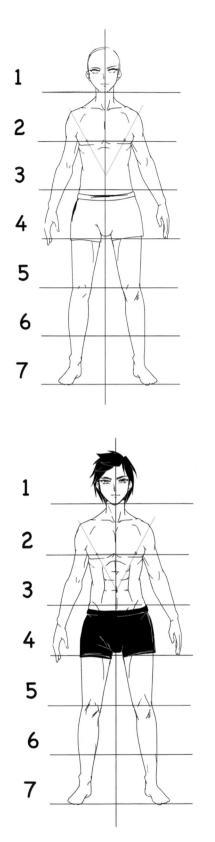

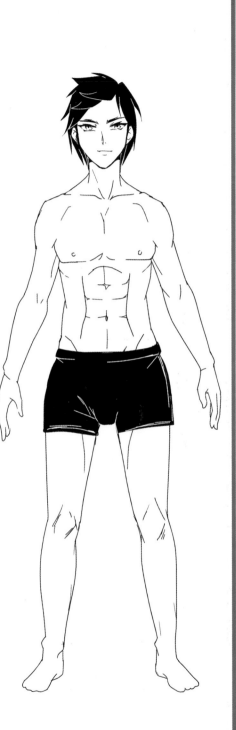

4 FINISH THE TORSO

Sketch where the torso should end, which is at the bottom of region 4. You may find characters with a longer torso with respect to legs. At the end of the day, it's the artist's choice.

5 ADD LEGS

Sketch the character's legs. The thighs decrease in thickness when approaching the knees. The knees fall at the bottom of region 5, and the calves taper down to the ankle. Then sketch your character's eyes.

6 FINAL DETAILS

Define the muscle lines. The more lines you add, the greater the masculinity of the character. You can add further details if you are interested in a more realistic manga style. Add hair, then ink and erase the guidelines.

Visit **impact-books.com/manga-workshop-characters** to download free bonus materials.

57

Male Side View

Now we will draw a side view of a male body. We are still following the 1:7 head-to-body ratio. Keep in mind that these rules are very generic, and the best way to learn is to study the human anatomy and to draw different poses at different angles. Practice makes perfect!

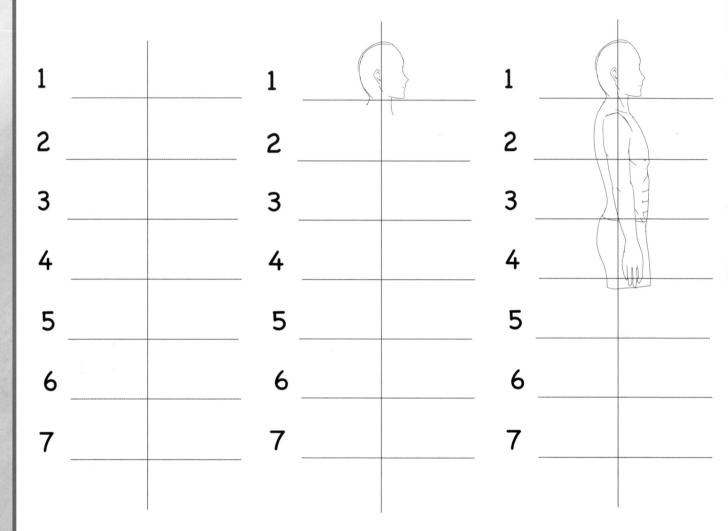

1 DRAW GUIDELINES
Begin by drawing seven equally spaced regions. These will act as a guideline to help you maintain correct proportions. Add a vertical (symmetry) line down the center.

2 SKETCH PROFILE
Sketch the character's profile head in the first region. Sketch the ears behind the vertical line.

3 ADD THE TORSO
The torso ends in region 4, and the elbow is in the center of region 3. Follow these rules to construct a proportionally sound upper body. The hand ends in region 4.

1 2 3 4 5 6 7

1 2 3 4 5 6 7

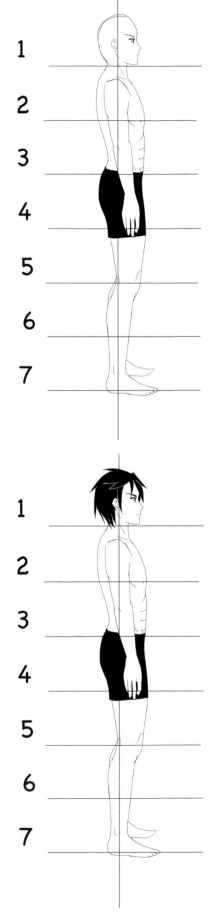

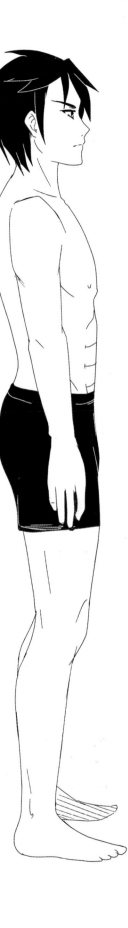

4 DRAW LEGS
Start sketching the character's legs. The knees are at the bottom of region 5 and the feet fall toward the end of region 7.

5 ADD DETAILS
Draw the character's eye and add more details to the muscles if needed.

6 FINAL DETAILS
Add hair, then add ink and erase the guidelines.

1 2 3 4 5 6 7

Drawing Hands

They say that hands are the most difficult to draw, not because of their complex structure but most likely because we are so familiar with how they look that we can spot the mistakes quickly. Artists usually have a hand model they follow or pictures of different hand gestures they can use when drawing. You can always go back to the source, which is human anatomy. Here we will learn different hand views and see some gestures.

Front View

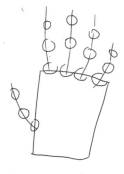 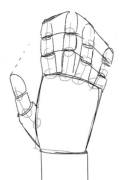 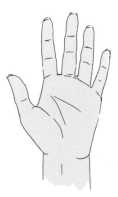

1 DRAW GUIDELINES
Start with a rough sketch of the palm and the five fingers. Use simple shapes for guidelines: a rectangle for the palm, circles for the joints. This is the front view of a left hand.

2 REFINE THE SKETCH
Follow the guidelines you have sketched in the first step to draw the full finger shapes. Observe the arch that's created and how the middle finger is the longest.

3 FINAL DETAILS
Follow the guidelines you have drawn to outline the shape of the hand. Make it as smooth as possible. Add some details, such as lines and the tips of fingernails, but make sure you don't add too many details because hands are simplified in manga.

Back View

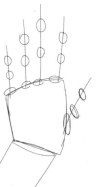 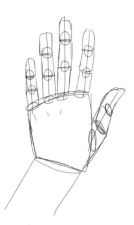 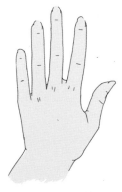

1 DRAW GUIDELINES
Follow the same pattern to draw the back of a hand. Observe the way the palm is tilted and the height of the fingers.

2 REFINE THE SKETCH
Roughly outline the guidelines you made in the previous step. Refine the fingers. Drawing cylinders makes it easier to draw.

3 FINAL DETAILS
Outline the sketch and add minor lines to make it realistic. The nails in manga art are usually outlined with no details, as shown here.

Side View

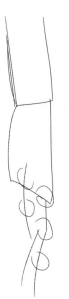
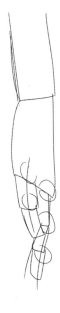

1 **DRAW GUIDELINES**
Sketch the side view of the hand with simple shapes. The thumb is most visible with the index finger showing.

2 **REFINE THE SKETCH**
Add more details, building up the dimension around the guidelines you created.

3 **FINAL DETAILS**
Finish drawing the hand shape. Add details, erase the guidelines and add color. The fingers behind the index finger may also show just a little, indicating an angled hand.

Hand References

You may want to look at your own hand for reference. Come up with different gestures with your hands and try to draw them on paper.

Visit **impact-books.com/manga-workshop-characters** to download free bonus materials.

61

Drawing Feet and Shoes

In this section we will go over different foot angles and take a look at some frequently used shoe types. It is important to understand the anatomy or the structure of the human foot. Drawing shoes is also important when designing a character. You need to look into different kinds and decide what works best for the character. What fits his or her personality?

Female Foot Top View

1 DRAW GUIDELINES
Sketch the basic structure. Observe the placement of the ankle bone and the way the foot and toes are curved. A female's foot is more delicate than a male's.

2 REFINE THE SKETCH
Outline the sketch you made, adding a little more detail. This is a simple representation of a female foot. The nails are slightly outlined.

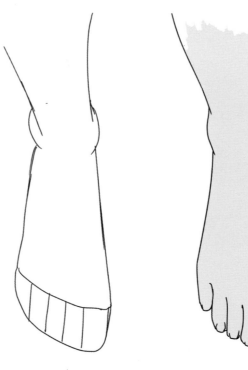

Male Foot Three-Quarter View

1 DRAW GUIDELINES
Create the sketch for a three-quarter view. In this case, the male foot is bulkier than the female foot. The toes are bigger and more rounded.

2 REFINE THE SKETCH
Follow the guidelines to outline and refine the drawing. Notice how the ankle bone is larger and more edgy than the one on the female foot.

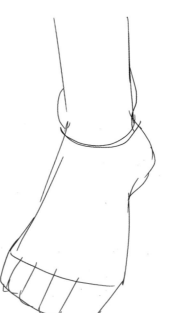
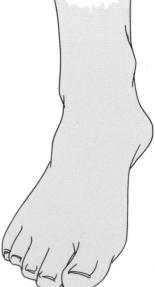

Female Foot Bottom View

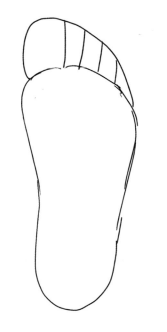
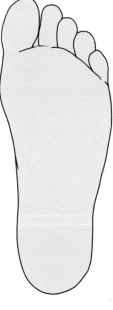

1 DRAW GUIDELINES

The bottom view is a little easier to draw but you may never need it in your manga. Use a long oval shape as a base. Notice the curvature of the toes and the slight curve near the heel.

2 REFINE THE SKETCH

Outline the guideline you sketched. Pay attention to the shape of the toes; they get increasingly smaller across the foot and can have an irregular shape from toe to toe.

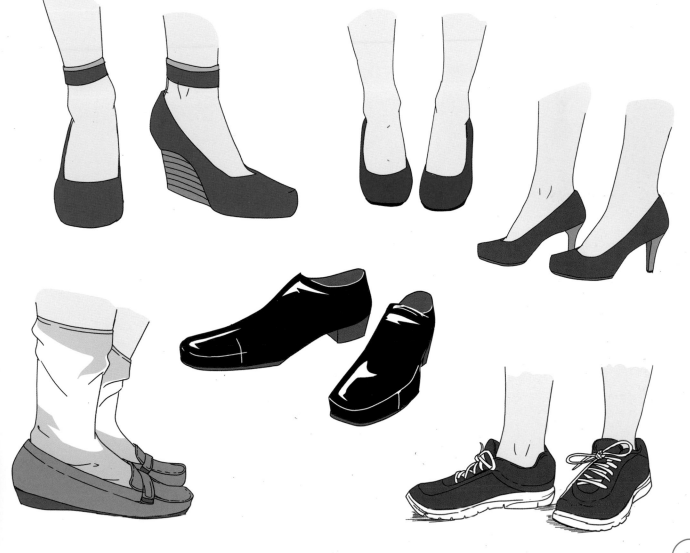

Visit **impact-books.com/manga-workshop-characters** to download free bonus materials.

63

CLOTHING STYLES

It is crucial to know how to draw clothes because you will be drawing a different outfit (or several) for every character you have. Fashion magazines or fantasy games can inspire you to create a unique outfit for your character. Costuming is a huge subject that you can find many books about. It is fun to come up with designs or color combinations of your own. In this section we will review a few options.

Female Clothing

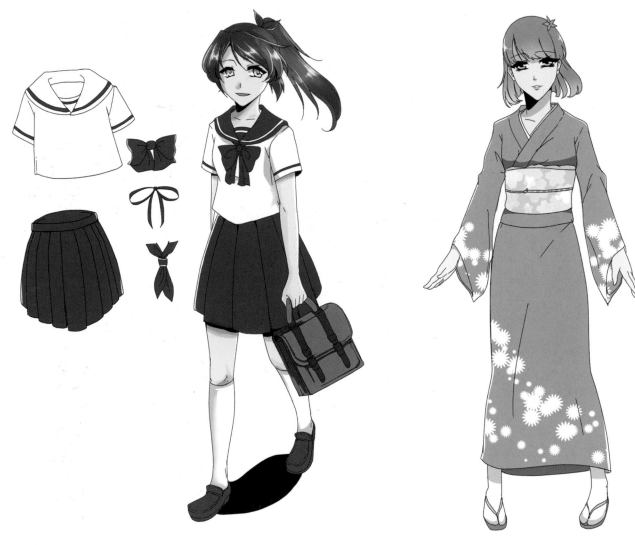

School Uniform

This is a typical schoolgirl uniform. If you are drawing a school story, you should research the different uniforms that exist and pick one that best represents or supports the theme of your story. Choose different colors or designs that you find the most convenient and attractive for the characters. In this example, there are different tie choices.

Kimono

This Japanese kimono showcases warm colors and a flower pattern. Flower patterns are common on kimono robes. You can research and find inspiration in the wide variety of designs that are available.

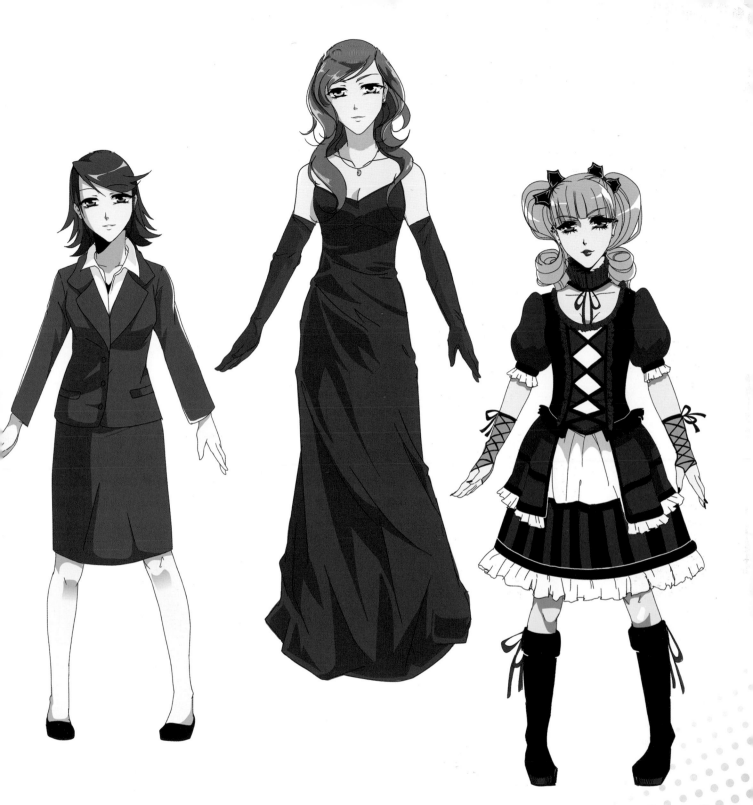

Business Suit

This suit can be used for an office employee. The color of a suit is usually dark with a white shirt underneath.

Formal Dress

This is an example of an elegant dress you may create when your character is going to a party. When it comes to dresses, you have unlimited options and designs. Look for design inspiration from fashion shows.

Gothic Lolita

This outfit is a good one for gothic/dark characters. It has elements resembling Victorian-era dresses, which are more challenging than most modern-day outfits because of their details.

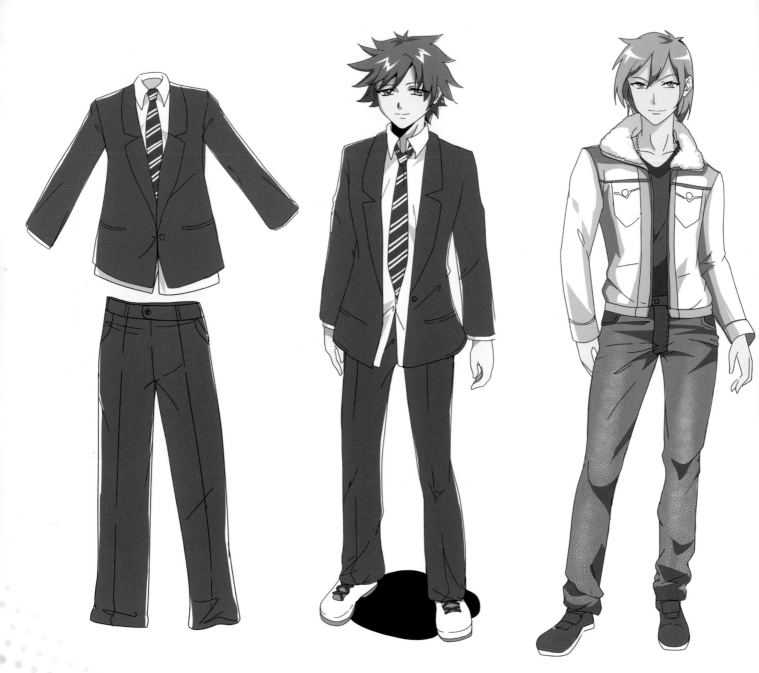

School Uniform

Boys' school uniforms are simple and consist of long pants, a button-down shirt and sometimes a suit jacket. A tie is worn in some schools but not in all of them. Study a lot of different uniforms! The more you expose yourself to different designs, the better your chances are of developing unique outfits. Unique outfits make unique characters, and unique characters are mostly loved and unforgettable.

Casual

This casual wear can be used for your nonfantasy stories. It is simple yet modern and stylish.

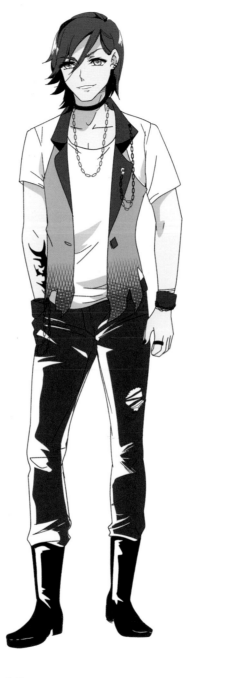

Business Suit

This is one of the most frequent outfits needed in manga stories. You will often find a man in a suit regardless of the theme, unless it's not applicable to the era of your manga.

Rock Star

Rock/punk and even gothic characters are becoming very popular in manga. A rock star is usually characterized by ripped shirts, leather pants, boots and jewelry. The folds in the pants give depth and resemble the leather material. Hopefully this outfit inspires you to create your own rock star manga!

Medieval Armor

Armor can be challenging to draw, but it's still a costume worth mentioning here. You'll need it for more epic fantasy stories.

POSES

The best approach to learning different poses is simply to sketch people in public. Knowledge of human anatomy is important when drawing poses, but what's more important is the overall pose. Is it dynamic or dull? Realistic or unnatural? Poses are challenging, but they are a key element to telling a story. Let's look at different poses for females and males.

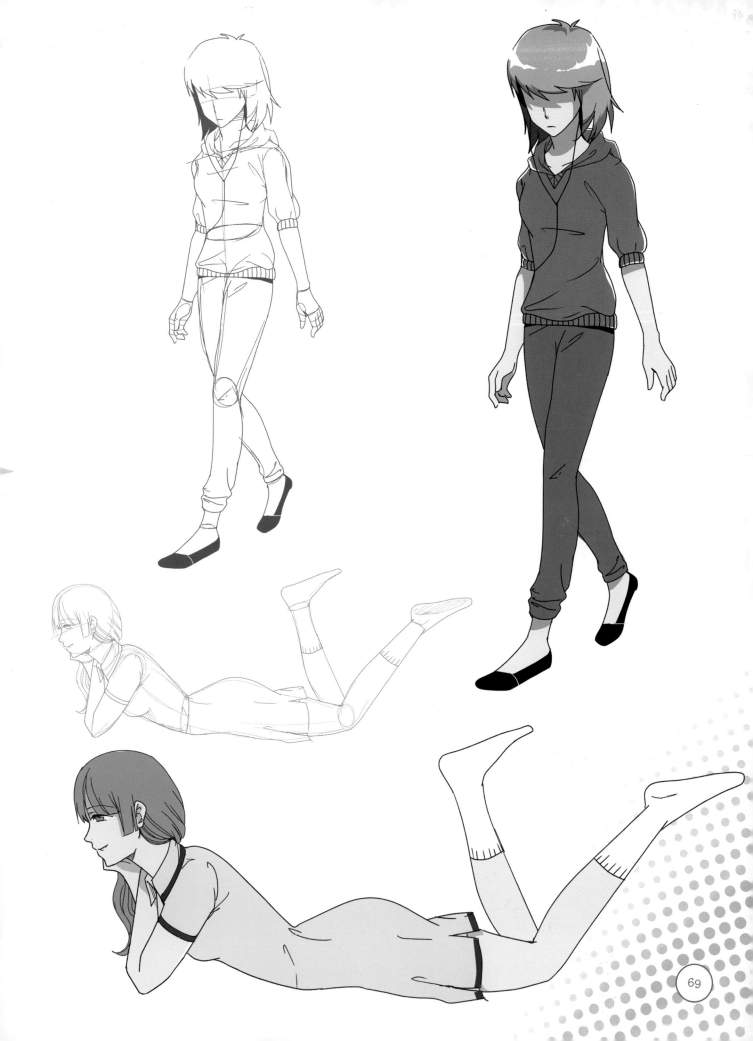

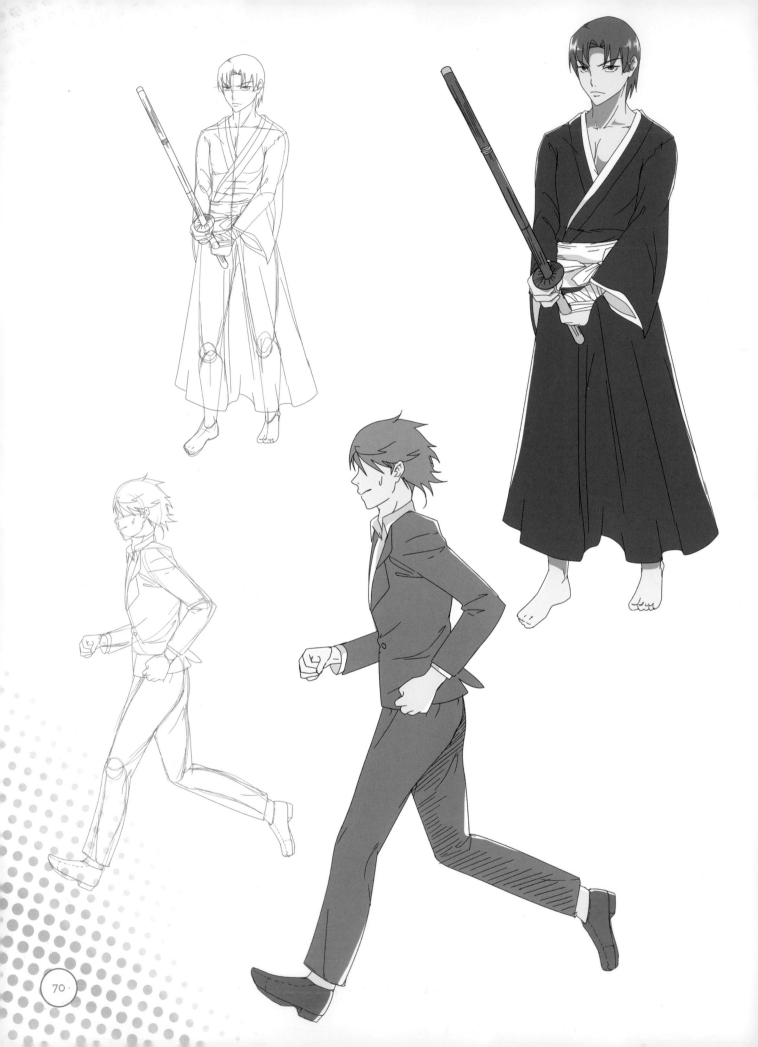

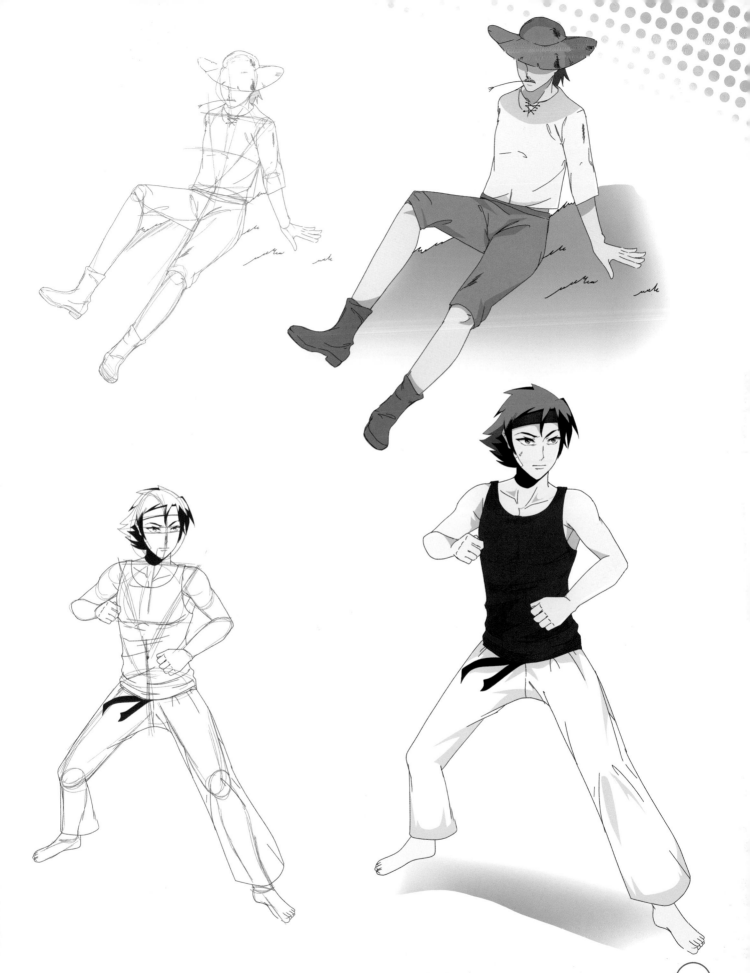

Visit **impact-books.com/manga-workshop-characters** to download free bonus materials.

71

How to Draw an Angel

Fantasy characters such as angels, vampires and witches are widely used in manga and there are established ideas of how each of them should look. The choice of following these concepts is fully yours. You may want to provide the industry with a new definition for a vampire or an entirely new creature you make up yourself!

Angels are peaceful, kind and good-looking. This demonstration will show you the steps to creating a manga-style angel. I have chosen a very basic costume, but you can add more details to it.

1 SKETCH THE FIGURE
Start off by sketching a basic standing pose for a male. I have sketched the face and hair as well. The hair has movement and adds majesty to the angel.

2 ADD DETAILS
Sketch the clothes and legs. I have chosen a Roman dress design for this angel. Then outline the arms and draw the shoes as shown.

3 SKETCH THE WING SHAPES
Erase the sketch lines. Add character details like the necklace and wristbands shown.

 Draw the basic shapes for two huge wings. They don't have to be exactly identical.

4 ADD FEATHERS
Start sketching the first layer of feathers as shown.

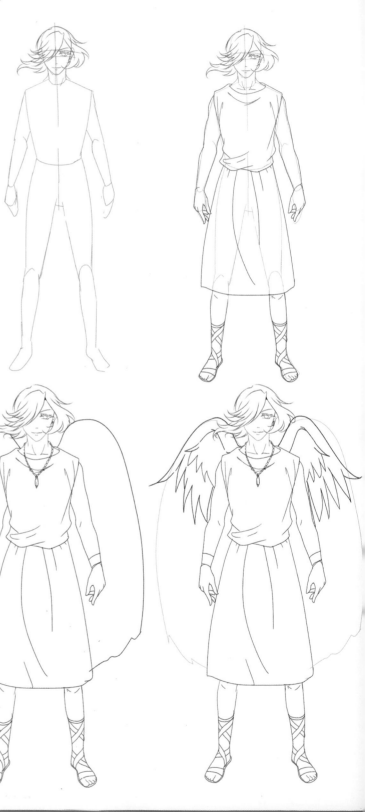

5 ADD MORE FEATHERS
Draw the second layer of feathers, which are longer than the first ones.

6 ADD FINAL FEATHERS
Draw the third layer of feathers, which are finer.

7 ADD COLOR
Erase the guidelines and add color to finish your angel.

Visit **impact-books.com/manga-workshop-characters** to download free bonus materials.

73

How to Draw a Vampire

Vampires are dark and mysterious. There's no way to mistake them for normal humans. In this demo, I will teach you step-by-step how to draw a scary vampire.

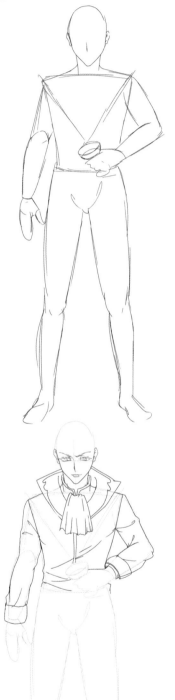
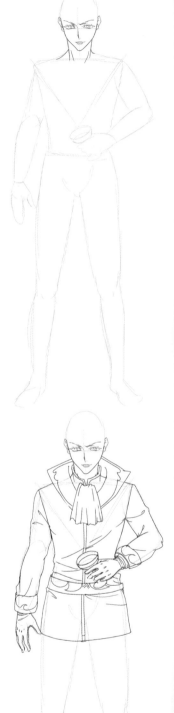

1 **SKETCH THE FIGURE**
Start off by drawing a rough sketch of the vampire's body, as shown in the previous demos. In this case, I want him to hold a bloody drink.

2 **DRAW THE FACE**
Draw the vampire's face. Notice the pointy teeth. The thin eyebrows add to his mysterious look.

3 **START ADDING DETAILS**
Start drawing the outfit. I chose a Victorian-era style because it suits this character's personality more than casual wear. Research and choose a design appropriate for your character.

4 **CONTINUE DRAWING THE COSTUME**
You can add gloves to enhance the look. Continue drawing the rest of the jacket, adding detailed trim around the waist and wrists.

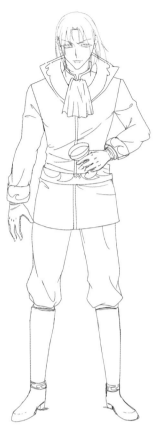

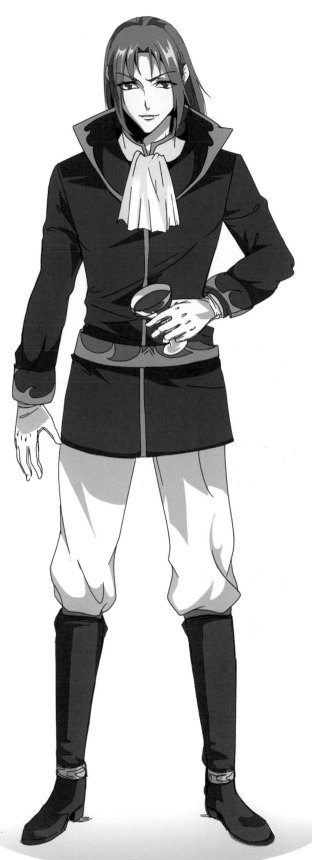

5 FINISH THE COSTUME

Finish the vampire's costume by drawing the pants and boots. Draw the basic shapes, then build up the details.

6 ADD HAIR

Draw the vampire's hair. Smooth, long strands fit this character's aura.

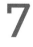

7 ADD COLOR

Erase the guidelines and apply colors. The glowing red eyes are perfect for a mysterious, blood-thirsty vampire.

Visit **impact-books.com/manga-workshop-characters** to download free bonus materials.

75

How to Draw a Witch

Witchcraft is a widespread theme in manga. There are many looks you can decide to have for your characters. In this demo, I chose the cute and classic witch character design.

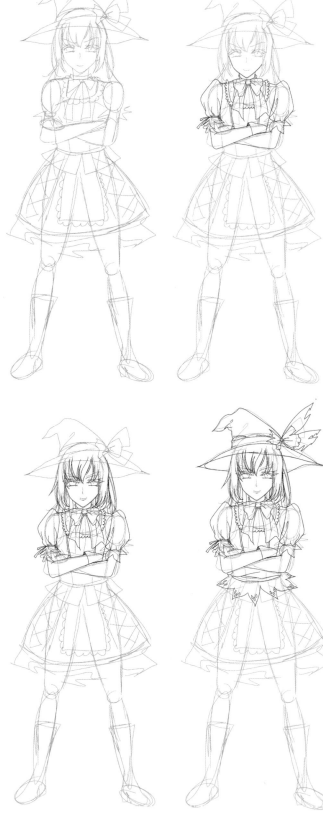

1 **SKETCH THE FIGURE**
Start by drawing a rough sketch of the witch design. Don't worry about being too accurate in this step.

2 **START OUTLINING**
Outline the sketch you have made, making clean lines. I start with the upper body.

3 **DRAW THE HAIR**
Draw the witch's hair, making sure it is smooth and straight. If you are unable to get this result, don't worry, it will come with time. Practice your line work on a separate piece of paper if needed.

4 **ADD THE HAT**
Draw the witch hat. It is usually pointed and wide brimmed. Don't forget interesting details like a ribbon or feathers.

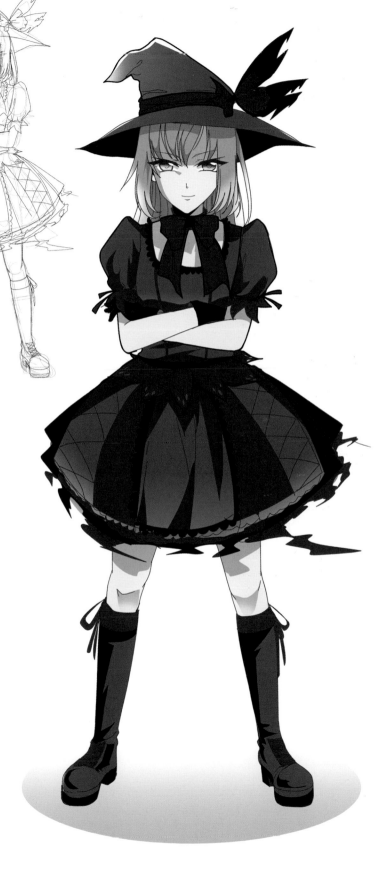

5 DRAW THE DRESS

Draw the character's dress as shown. Don't be afraid to experiment with different dress designs. I drew tattered ends flying off the edge to enhance the gothic look.

6 FINAL DETAILS

Finish the costume by drawing the witch's legs and chunky-heeled boots. A witch usually has a broom and is accompanied by a black cat or bats. You may want to add those extra details to your design.

7 ADD COLOR

Erase the sketch lines you drew by hand, or hide the sketch layer if you are creating this digitally. Then add color and your witch is complete.

Visit **impact-books.com/manga-workshop-characters** to download free bonus materials.

77

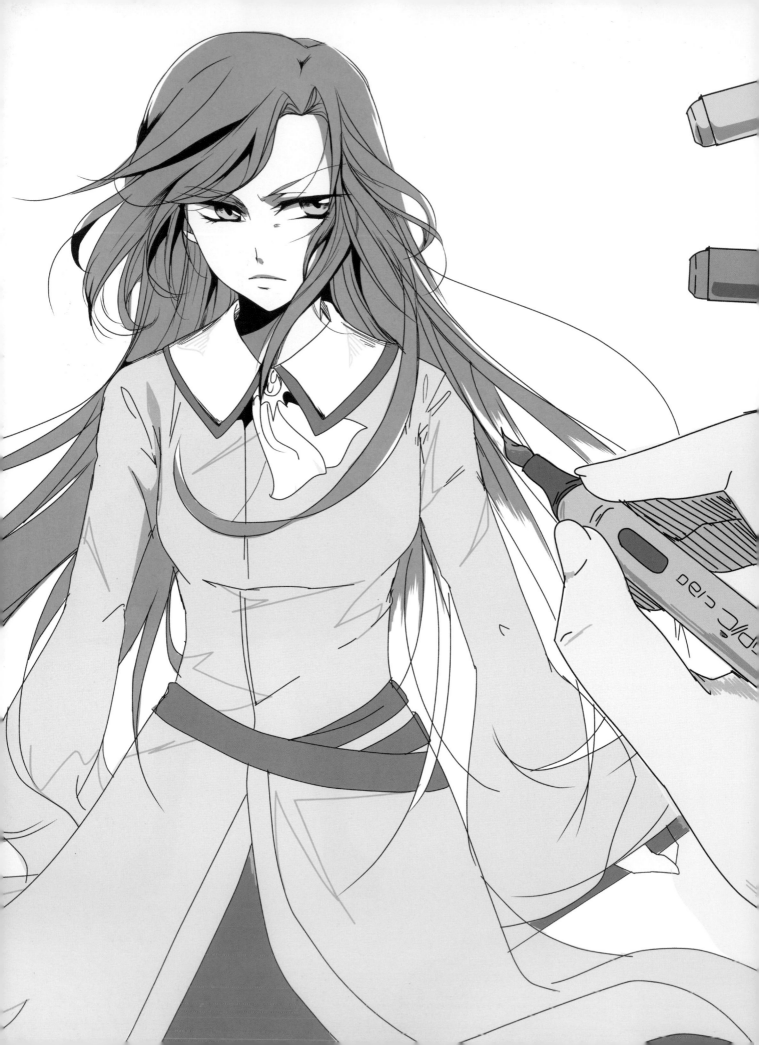

Part 3
Coloring

Colors can add life to your drawings. You will want multiple colored illustrations in your manga book. At least three is usually a good number. In this chapter, we will learn how to color with colored pencils, Copic markers and digitally with Manga Studio®. Then I'll talk about my manga and provide demonstrations for my manga characters and the process involved in drawing a page.

Coloring with Colored Pencils

Colored pencils are a common coloring method for manga. They are easy to use and inexpensive compared to other art supplies. I have used colored pencils in the past to color my drawings and the results were extremely good. You may use soft pastels with colored pencils for smoother shading. This demonstration features how to color line art with colored pencils.

MATERIALS LIST

eraser
Faber-Castell watercolor pencils
paper
pen
pencil

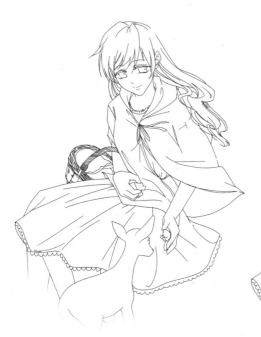

1 SKETCH AND INK THE FIGURE
Sketch the figure with a pencil, then ink the lines and erase the sketch. Once your line art is finished, get ready to add color. For this little red riding hood girl, start with three different skin colors. We will use nos. 432, 430 and 478 (a peach, a light orange and a medium shade of brown).

2 ADD THE FIRST LAYER OF COLOR
Start by gently coloring the first base of the skin with the no. 432 pencil. You can leave some areas in the face uncolored for the highlights.

3 ADD SHADING TO THE SKIN
Start shading with no. 430. Color the areas with dark shadow such as the forehead, neck and arms. Use a medium brown, no. 478, to add further shading in the neck and forehead. It's the shading that adds dimension to the drawing.

We have called out specific numbers in this coloring demonstration but please be aware that the colors can differ based on the brand, geography, age or set of colored pencils that you choose.

4 START COLORING THE HAIR

I used no. 419, 430, 434 and 476 (a light pink, a light orange, purple and a dark brown) for the hair color. Start with the lighter pink color, no. 419, and color all the hair, leaving just a few white areas on the top for highlights.

5 CONTINUE BUILDING UP THE HAIR LAYERS

Use a darker shade of purple, no. 434, and apply it in areas with heavy shadow.

6 FINISH COLORING THE HAIR

Use no. 430, the light orange color, throughout the hair to add variety, leaving some white areas on the top for highlights. This color blends the two previous colors and results in a more vibrant look.

Use a dark brown color, no. 476, to darken the areas with heavy shading, usually behind the character's neck and slightly on the top of the head.

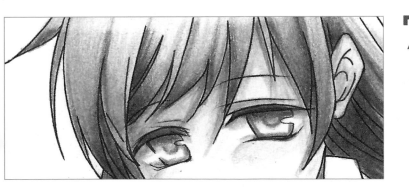

7 COLOR THE EYES

Color the eyes with brown using nos. 487, 478 and 476. If you are not using the same color set, you can just use three different shades of brown.

Apply the first layer of color with the lightest shade of brown, no. 487.

Then use the darker color, no. 478, to darken the pupil of the eye. Make sure that you keep the iris as light as possible.

Use the darkest shade of brown, no. 476, to color the upper part of the eye and slightly shade the pupil.

8 COLOR THE CAPE

Use a medium red color, such as no. 421, for the cape. When coloring the first layer, keep some areas light for highlights and darken other areas with heavy shadow. This can be achieved by placing more or less pressure on the pencil. In this way, you can add dimension using only one pencil!

9 ADD SHADOWS TO THE CAPE

Apply a darker red colored pencil, such as no. 426, in areas with heavy shadow: the folds and beneath her hands.

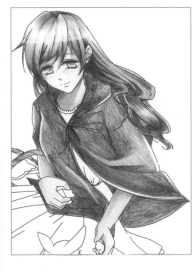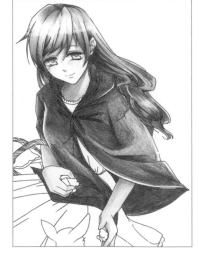

Visit **impact-books.com/manga-workshop-characters** to download free bonus materials.

81

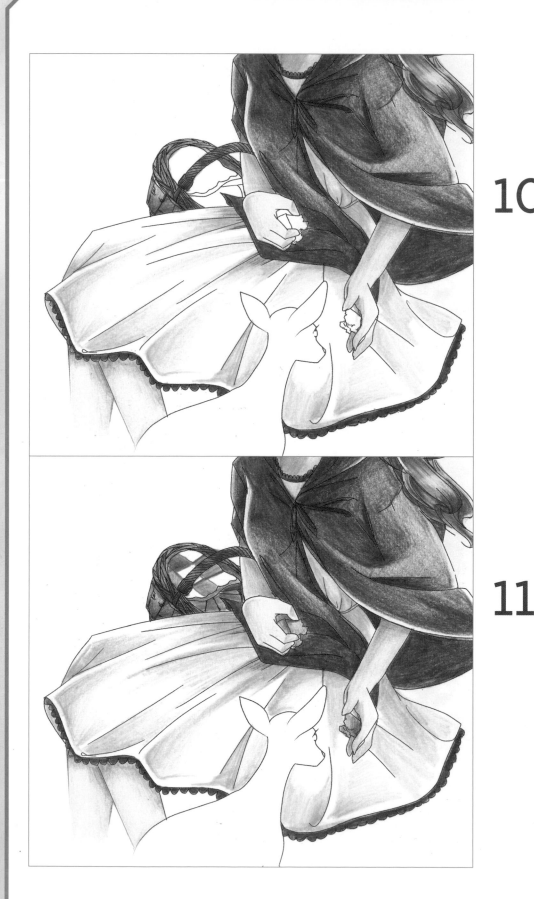

10 COLOR THE DRESS AND BASKET

Use color no. 432 (a peach color) to color the dress. Notice how the folds are colored. Use the same pressure technique you used to color the cape. Color in the brown basket with no. 478 (a medium brown).

11 FINISH THE BASKET AND DRESS

Use two shades of blue, nos. 451 and 445 (a dark and light blue), to color the cloth in the basket. Outline the squares with the dark blue and color them in with the lighter blue. Don't forget to add the cakes as well! Once you finish the basket, add extra shadows to the dress with no. 430 (a light orange).

12 COLOR THE DEER

Use nos. 487, 478, 476 and 480 to color the little deer. Apply the first layer of coloring using light brown, no. 487. Then add shadows to the ears, face and back with a medium brown, no. 478.

13 FINAL DETAILS

Add the spotty texture on the back of the deer with a dark brown, no. 476, and a medium brown, no. 478. Use the darkest brown, no. 480, to darken the deer's fur for added dimension.

Visit **impact-books.com/manga-workshop-characters** to download free bonus materials.

83

Coloring with Copic Markers

Copic markers require a fairly simple technique that results in beautiful illustrations resembling watercolors. You can start with only five markers if you don't have the budget for a pack of thirty-six or seventy-two. For an artist who craves coloring, I find them entertaining to use, although sometimes it can take more than four hours to complete an illustration. In this demo, we will use the same drawing we colored with pencils so that we can compare the results. You can either do the line art traditionally, or create your line art in Manga Studio and print it out.

MATERIALS LIST

colored pencils
Copic Sketch markers, 72-color
Set D, selected colors
eraser
pen
pencil

1 SKETCH AND INK THE FIGURE

Sketch the figure with a pencil. Then either ink the art traditionally, or digitally ink the art and print it out with Manga Studio. This is the line art that we are going to color.

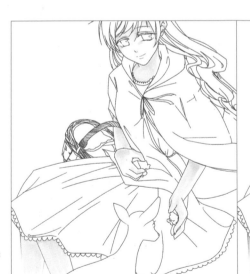

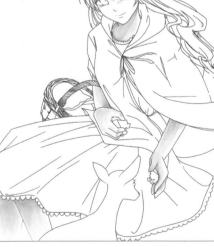

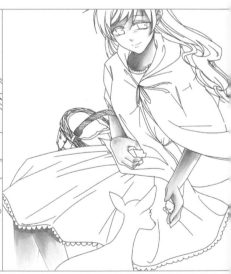

2 COLOR THE BASE OF THE SKIN

Use the lightest cream marker to color the base of the skin. Marker E01 (Pink Flamingo) is a good base color.

3 BUILD UP THE SKIN LAYERS

You don't have to color the entire skin. Leaving white areas in the face and body is a good idea for highlights.

Next use a darker shade, such as E95 (Flesh Pink), to darken areas with heavy shadow, such as the neck, hands and legs.

4 FINISH ADDING SHADOWS ON THE SKIN

Apply marker E93 (Tea Rose) to blend the shades together.

Apply marker E04 (Lipstick Natural) for further shading. This is my favorite color when it comes to shading the skin. Finally, add RV42 (Salmon Pink) to finish the skin layers and blend the colors.

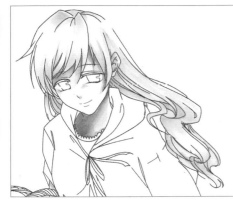

5 START COLORING THE HAIR

Color the base of the hair with V91 (Pale Grape), leaving some white areas for highlights. Always start coloring with a light color, then darken and build up layers.

6 ADD SHADOW TO THE HAIR

Apply a darker shade, such as V95 (Light Grape), on the edges of the hair. Then apply V91 (Pale Grape) to blend these colors together. Remember which direction your light source is coming from. Add the color, making sure to darken the areas with heavy shadow.

7 FINISH THE HAIR AND START THE EYES

Apply E71 (Champagne) or any pink color over the hair to give it more depth and warmth.

Use a pale color such as V91 (Pale Grape) to color the first layer in the eyes.

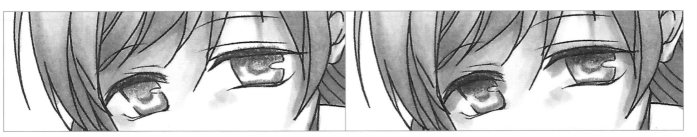

8 OUTLINE THE EYES

Use a dark brown colored pencil to outline the pupil. I always use colored pencils for this step because the tip is smaller than a marker's and therefore you have more control over it.

9 FINISH THE EYES

Use colored pencils to finish building up the layers in the eyes. Adding shadows will help give the eyes dimension.

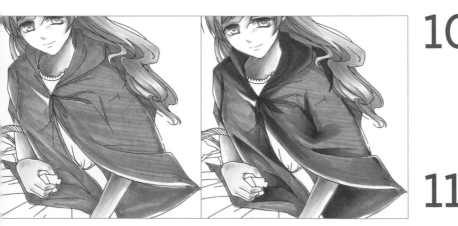

10 ADD COLOR TO THE CAPE

Apply the red color for the cape. R14 (Light Rouge) is a good choice. Notice the way I'm coloring the cape. The direction of the marker strokes can add shape to the fabric. You can control the intensity of the color by going over the areas you have colored with the same marker again, building up the layers.

11 ADD SHADOWS

Build up the shadows in the folds by applying a darker marker, such as R46 (Strong Red).

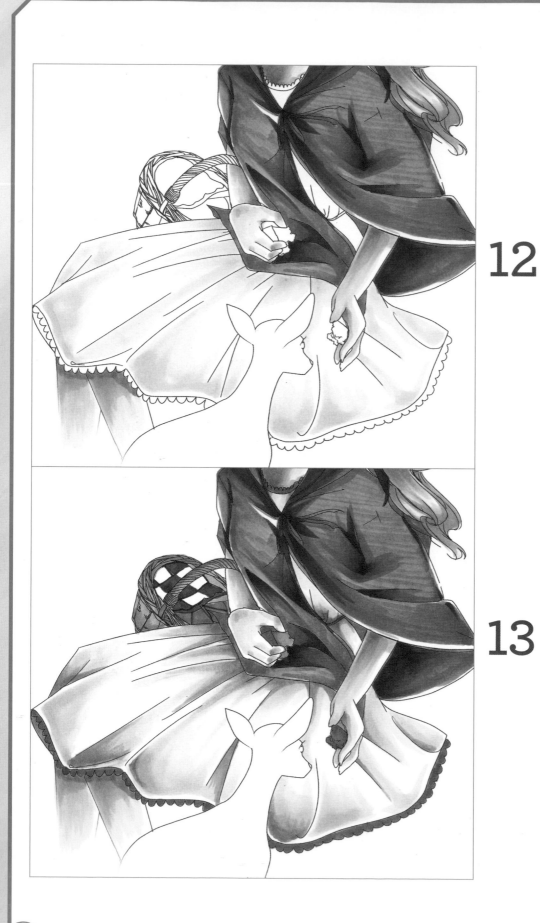

12 COLOR THE DRESS

Use a pale pink marker, such as R30 (Pale Yellowish Pink), to color the dress, leaving some white spots for highlights.

13 ADD SHADOWS AND COLOR THE BASKET

Use marker E04 (Lipstick Natural) to add shading to the folds of the dress. Next use brown E97 (Deep Orange) and then dark brown E74 (Cocoa Brown) to color the basket and apply shadows. Color the basket cloth with blue B28 (Royal Blue).

14 COLOR THE DEER

To color the deer, first use a light brown color such as E97 (Deep Orange).

15 FINAL DETAILS

Using dark brown colors, such as E47 (Dark Brown) or E74 (Cocoa Brown), color the texture of the deer fur, adding spots and shadows.

Visit **impact-books.com/manga-workshop-characters** to download free bonus materials.

87

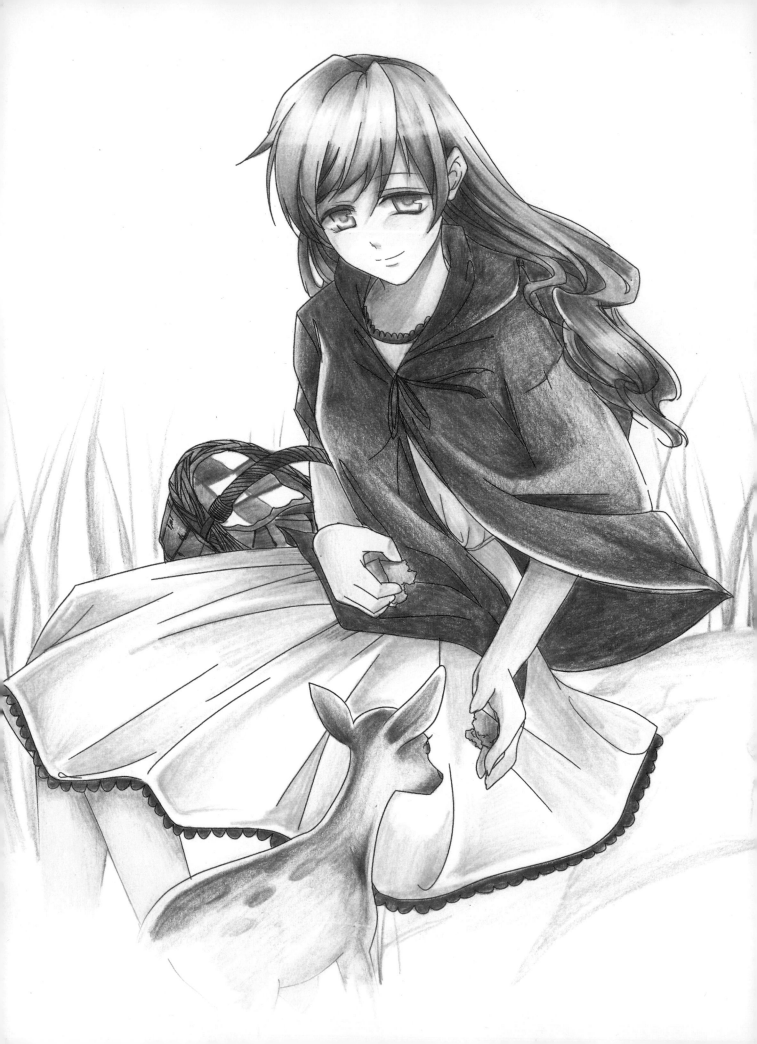

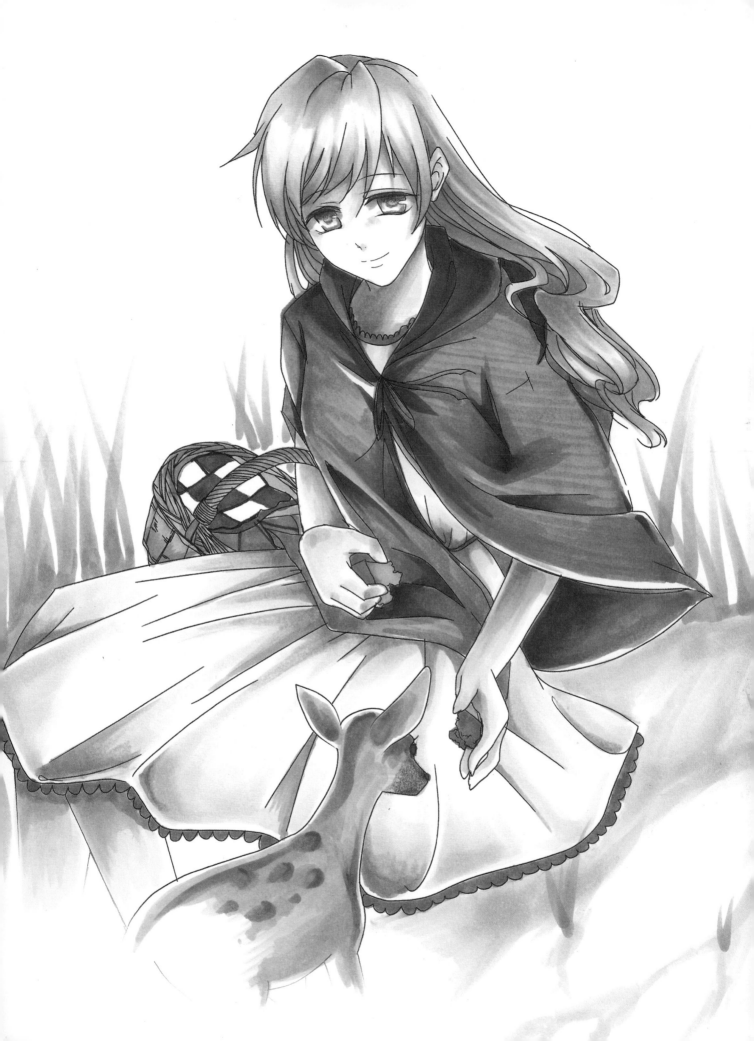

Coloring with Manga Studio

I decided to include a Manga Studio tutorial in this book because the program is straightforward, easy to use and important to learn if you're going to create a manga. Just follow the steps I use to digitally color this artwork. I'm using Manga Studio EX 4 and a Wacom Intuos 5 tablet. It can be hard to work with a tablet at first, but with practice it becomes easier. Using a tablet will help you achieve cleaner results and saves you the cost of art supplies. Remember to save your work at least every fifteen minutes to avoid having to repeat the drawing in case the software crashes.

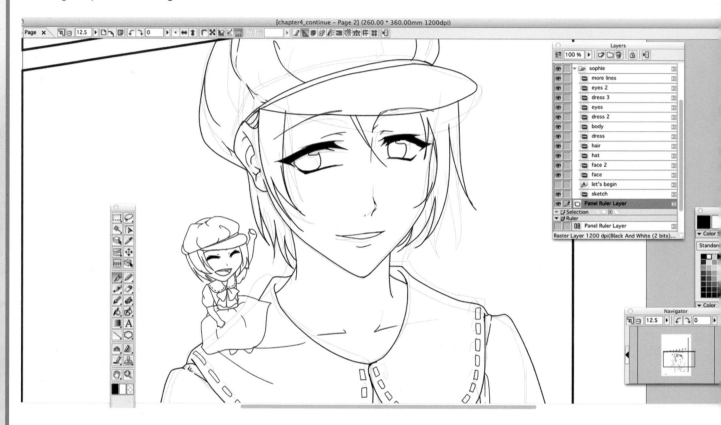

1 CREATE THE DRAWING IN LAYERS

In this drawing, we have something called "layers." The first layer is named "sketch," which is your primary sketch, and then in a folder you have layers for the line art (or outlining). I like to draw every part in a different layer to keep it clean and organized.

Folder Order Matters

The color folder must be below the line art layers folder so that you can see your line art while coloring.

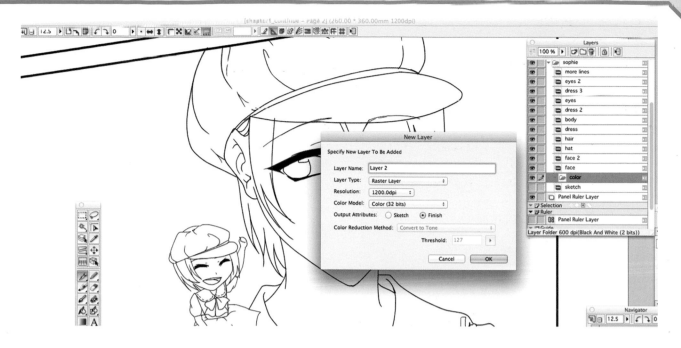

2 FOLDERS

Hide the sketch layer by clicking the eye icon to the left. Create a new folder and name it "color."

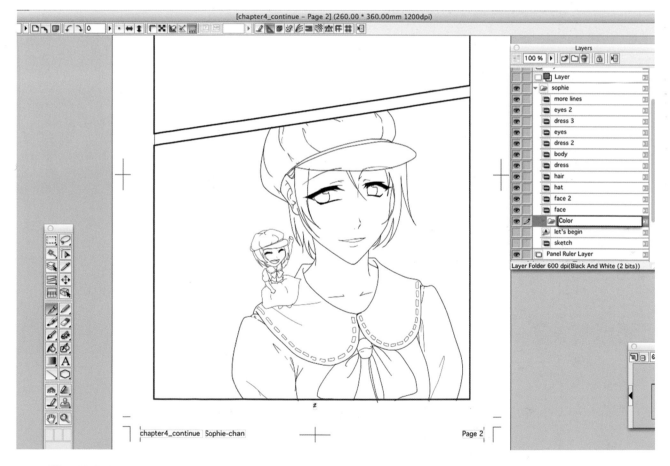

3 ADD A COLOR LAYER

Add a new layer, making sure that the color model is Color (32 bits) to enable the use of colors. The default setting is black and white because it assumes you are drawing a standard manga page.

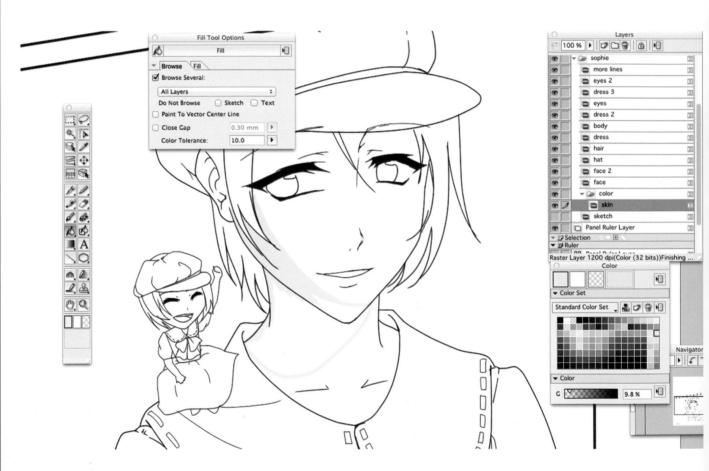

4 RENAME THE LAYER

Rename the new layer "skin." Appropriate labeling is very important! Select the pen tool from the tool menu. Select the skin color from the available colors in the color table on the right.

5 START COLORING THE SKIN

Start coloring the skin with the pen tool. You can also use the fill tool to color faster, but make sure the shapes are enclosed or else the fill tool will fill your entire page (which becomes annoying when you are working on large files). If you select all layers, the tool will take all lines into account. But if you select this layer (skin), it will only consider the layer you are working on.

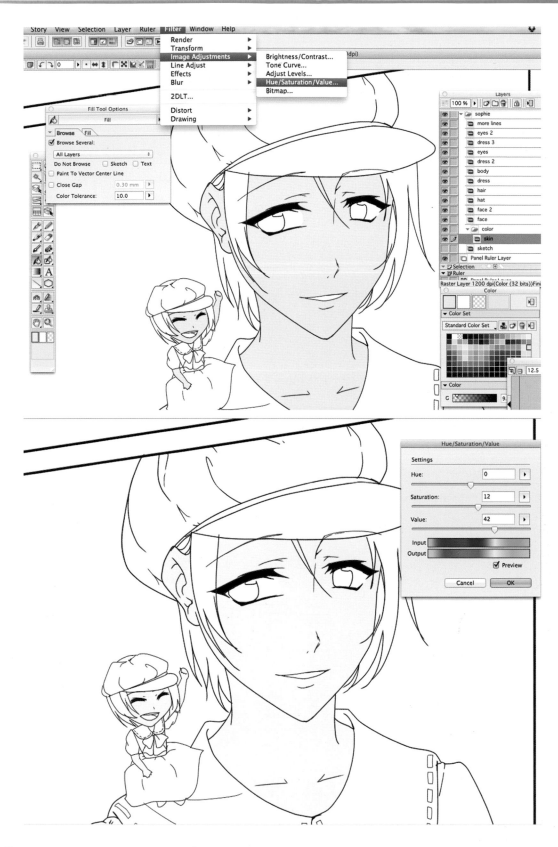

6 ADJUST THE COLOR

Now, after you have finished coloring the face, you can go to Filter > Image Adjustments > Hue/Saturation/Value to alter the color. For example, if you want to make the face lighter, increase the value, which will increase the brightness.

7 CREATE A NEW LAYER

Create a new layer and name it "skin 2." This will be the shading layer.

8 START SHADING

Select a darker pink to shade the face. Select the pen tool. Under the pen tool options you can select "Stroke-in" and "Stroke-out." That will yield a finer ink pen line, which is what I generally use to ink my manga pages.

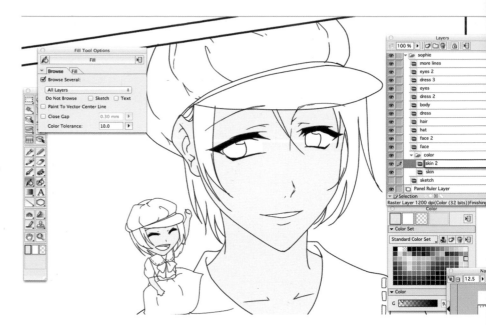

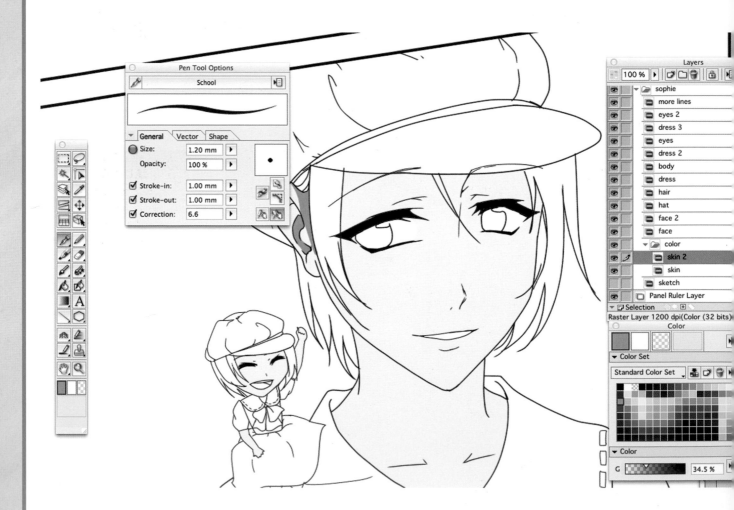

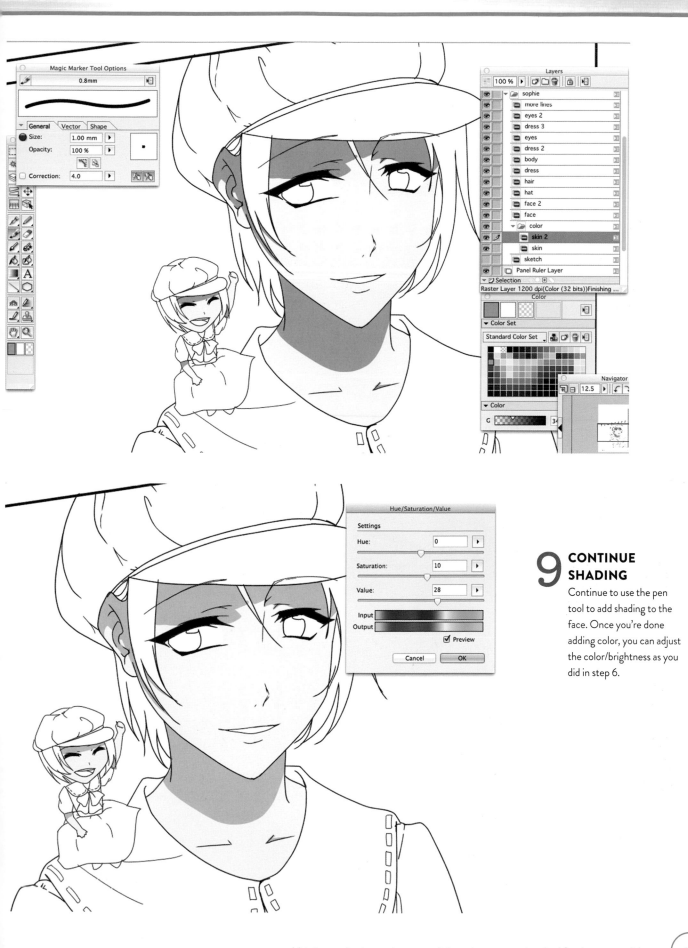

9 CONTINUE SHADING

Continue to use the pen tool to add shading to the face. Once you're done adding color, you can adjust the color/brightness as you did in step 6.

Visit **impact-books.com/manga-workshop-characters** to download free bonus materials.

95

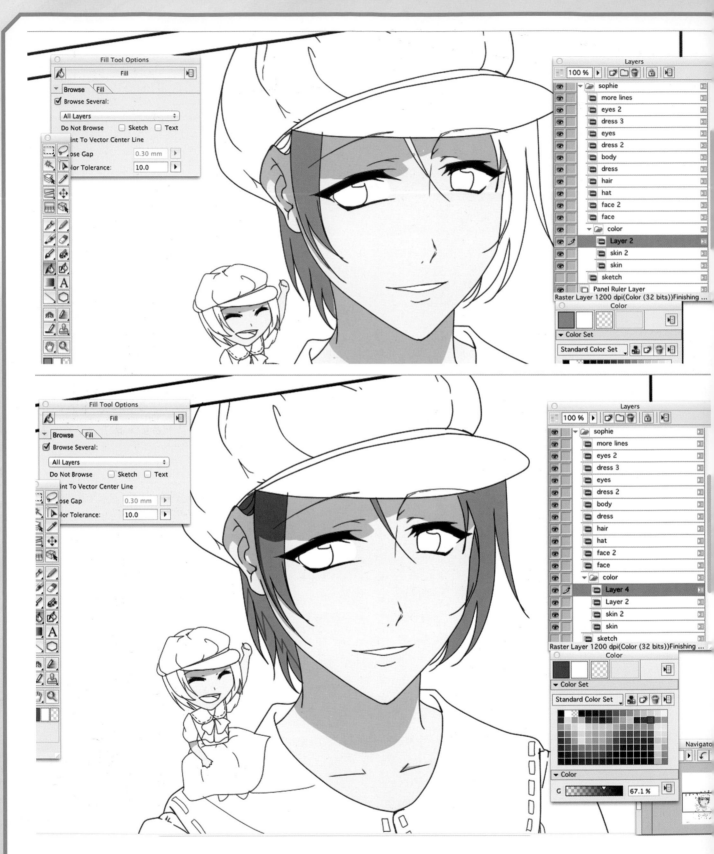

10 ADD HAIR LAYERS

Create a new layer and start coloring the hair. Then create another layer for the shading of the hair. Select a darker color than the one you used to color the hair.

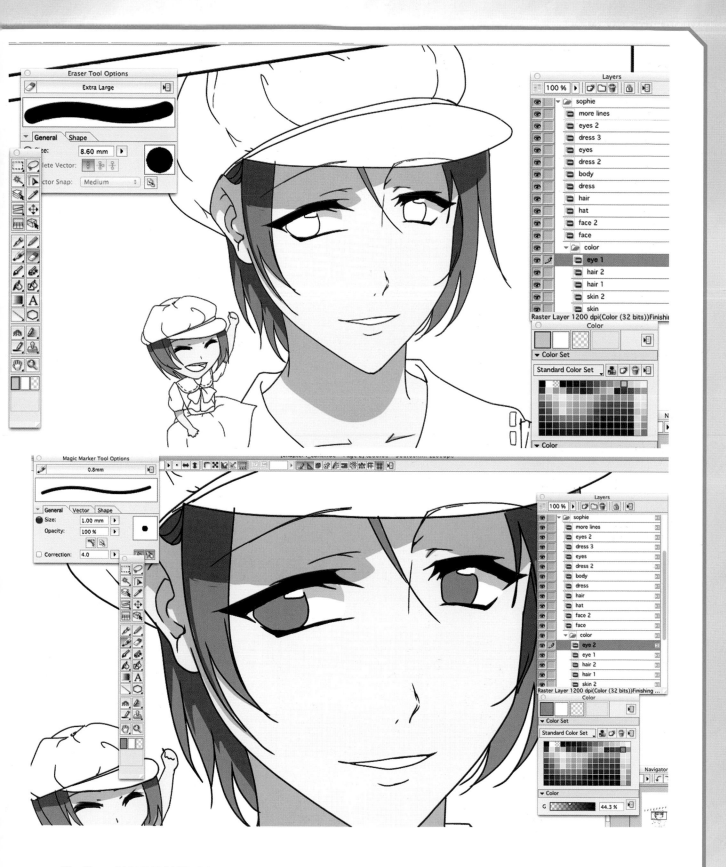

11 SHADE AND COLOR THE EYES

Create a new layer for the eyes. Use a light gray color to shade the eyes. Then create a new layer and color the irises as shown.

Visit **impact-books.com/manga-workshop-characters** to download free bonus materials.

97

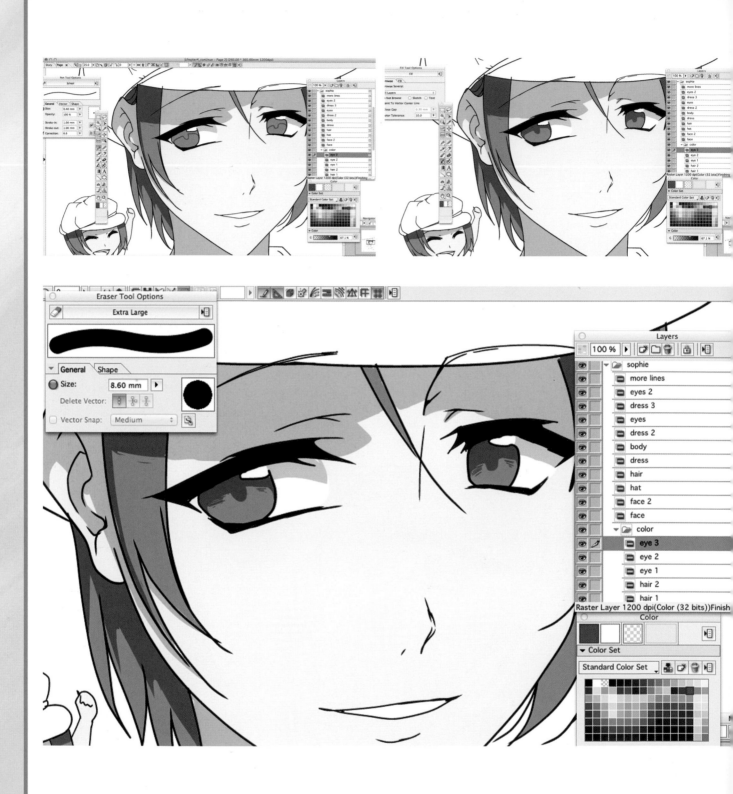

12 MAKE PUPILS AND ADD SHADING

Create a new layer for the darker eye shades (including the pupil). Use the pen tool to draw the shape of the shadow and pupil and then use the fill tool to color that shape entirely. You may also add a few lines in the same layer to give the eyes more depth.

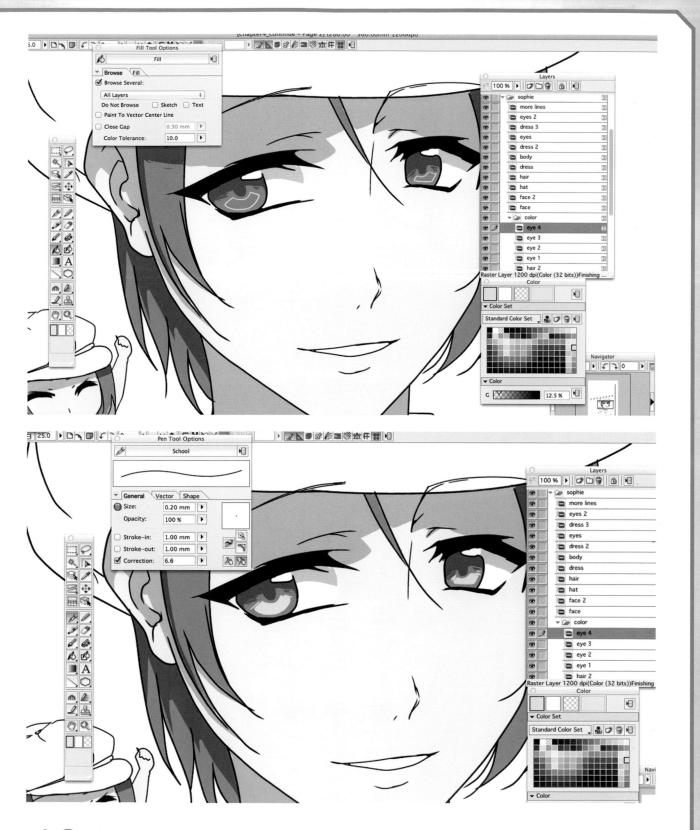

13 CREATE THE EYE HIGHLIGHTS

Create a new layer to draw the eye highlights. Outline the shape of the highlight first with the pen tool and then color it with the fill tool. Again you can add some lines on the edges of the highlights for more depth.

Visit **impact-books.com/manga-workshop-characters** to download free bonus materials.

99

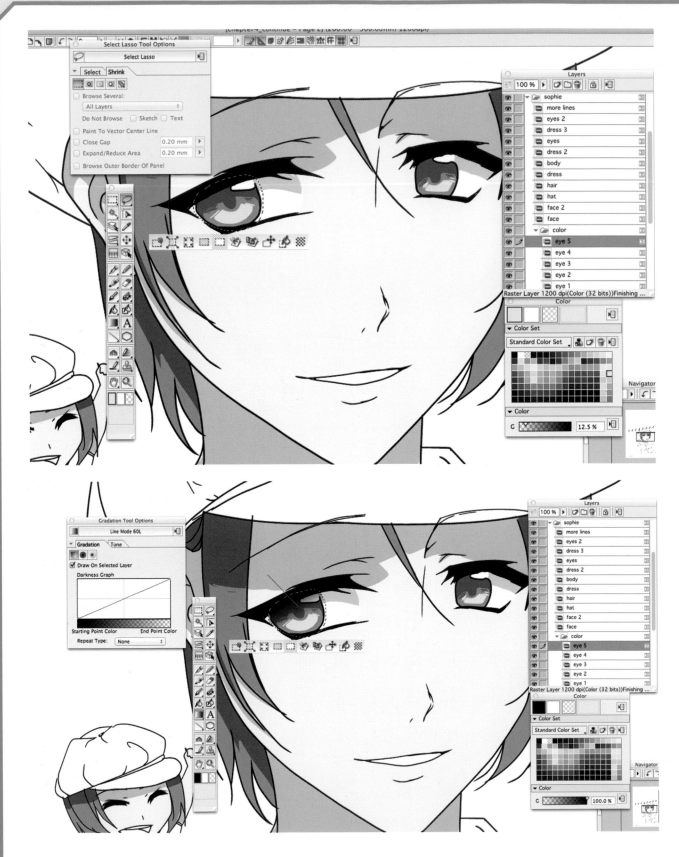

14 ADD GRADATION

You can also use the lasso tool to select the eye circle (containing the iris and pupil), then click on the gradation tool to create a slight gradation that makes the eyes look more realistic and three-dimensional. With the gradation tool, the longer the line you draw, the higher the intensity of color.

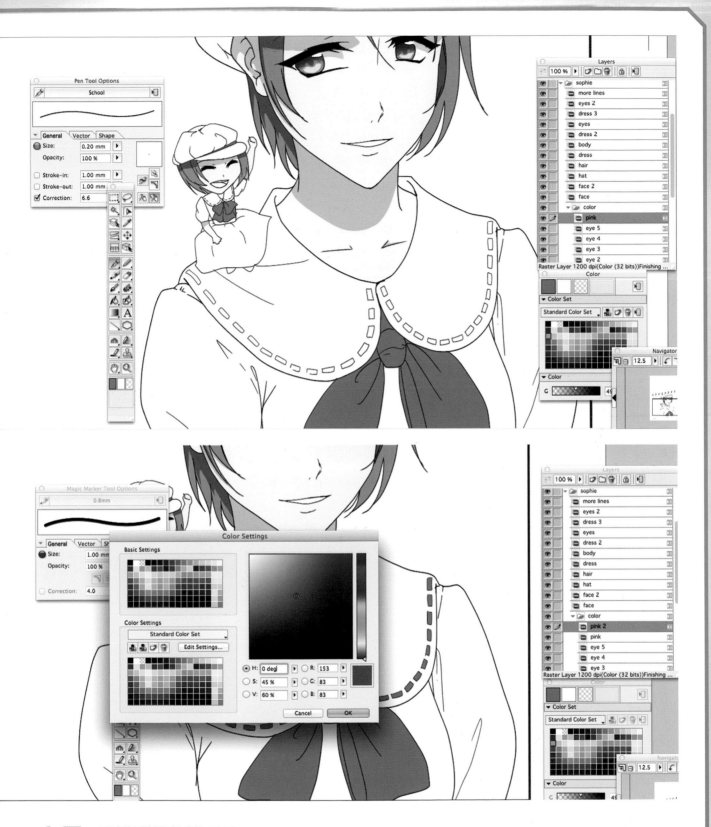

15 BEGIN THE CLOTHING

Make a new layer for the pink tie and collar trim. Follow the same coloring steps every time. Use the pen and fill tools.

Now create a new layer for the shading. If you click the color tool, you can see the color settings and pick the color you want for the shading. This is an easy way to get a slightly darker shade of a color you're already using.

Visit **impact-books.com/manga-workshop-characters** to download free bonus materials.

101

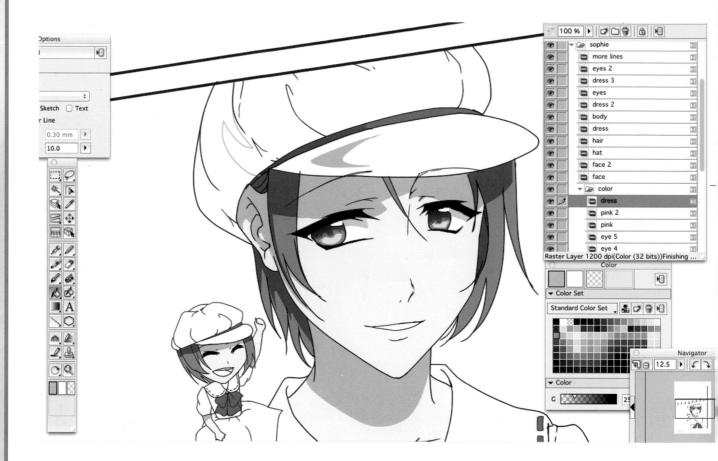

16 DRESS SHADING

Repeat the same techniques you've been using for color and add shading to the hat and dress. You can either use gray or a light pink to shade the white clothing. I personally prefer pink, but it depends on the character and the type of light directed on them. Then color the mouth.

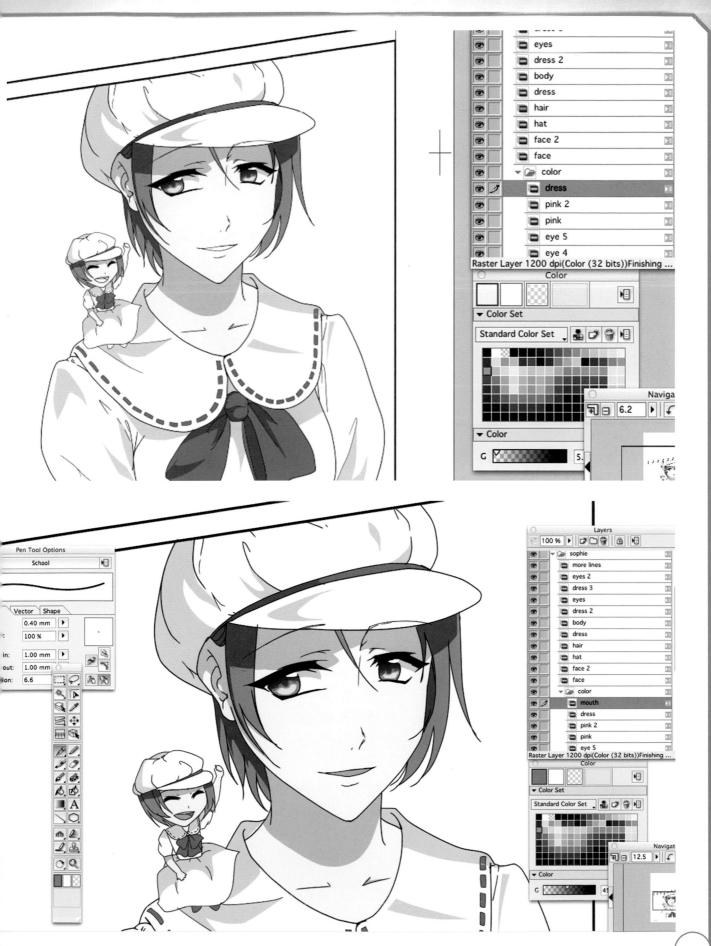

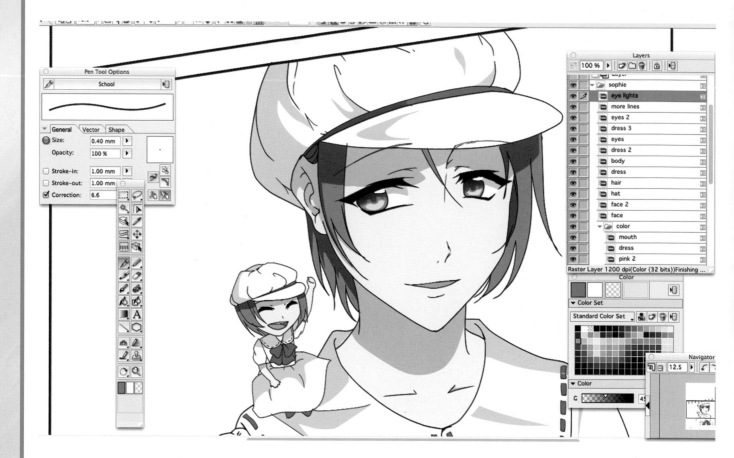

17

FINAL DETAILS

Create a new layer and call it "eye lights." Make sure to place it *above* your line art files. Then use the pen tool to adjust the eye highlight and give it more depth. Drag the eye lights layer to the top. Having this layer above your line art will help you color over them for final touches. Use the pen tool to draw a thicker line around the character to give it more depth.

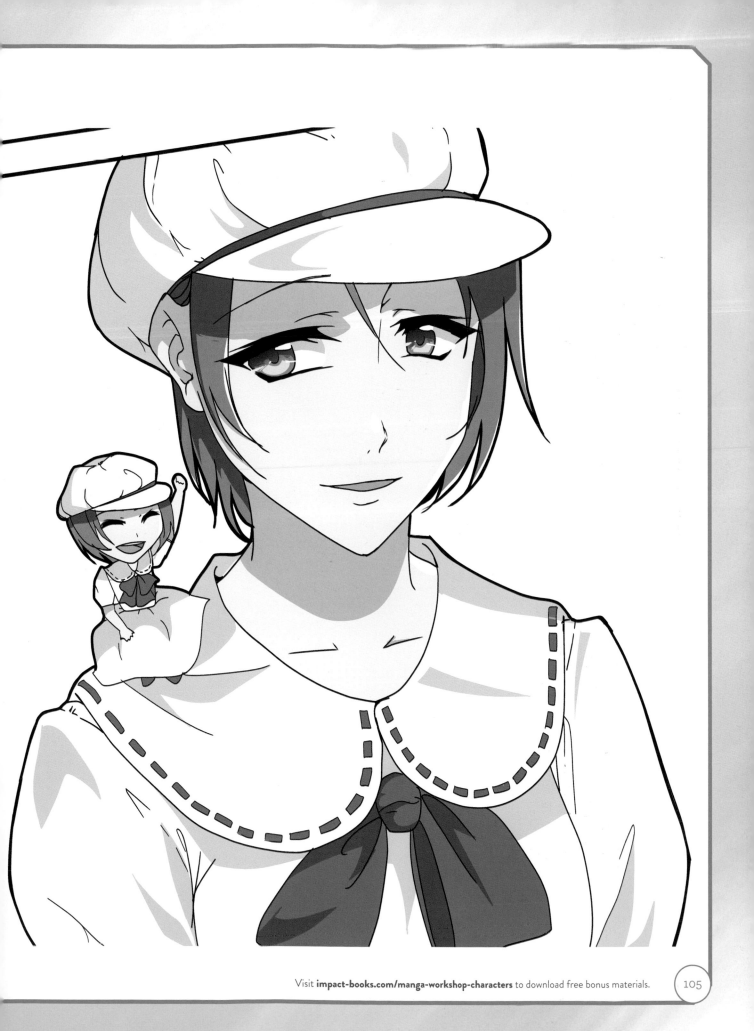

Visit **impact-books.com/manga-workshop-characters** to download free bonus materials.

105

Drawing a Manga Page

In this demo, I will show you the steps to create a manga page. After fully writing your manga story and sketching every page, you will then need to draw, ink, tone and add text.

1 STORYBOARDING

Storyboard sketches and thumbnails help you plan the pages for the entire story. The sketches are rough but give a basic idea of where every character is placed and the dialogue between them. You may change the storyboard at any time, but it is a guide to help you plan your story better and see where it's going. I like to keep it as simple as possible with only the main elements showing, such as the characters, settings and text.

2 SKETCHING

Next create a more accurate sketch of your page on new paper or a new page in Manga Studio. In this stage, refer to the character profiles you have made for each character as you sketch them, making sure to get their character details right. You may use a pencil, if you are using traditional mediums, or the pen tool in a separate layer, if you are using Manga Studio.

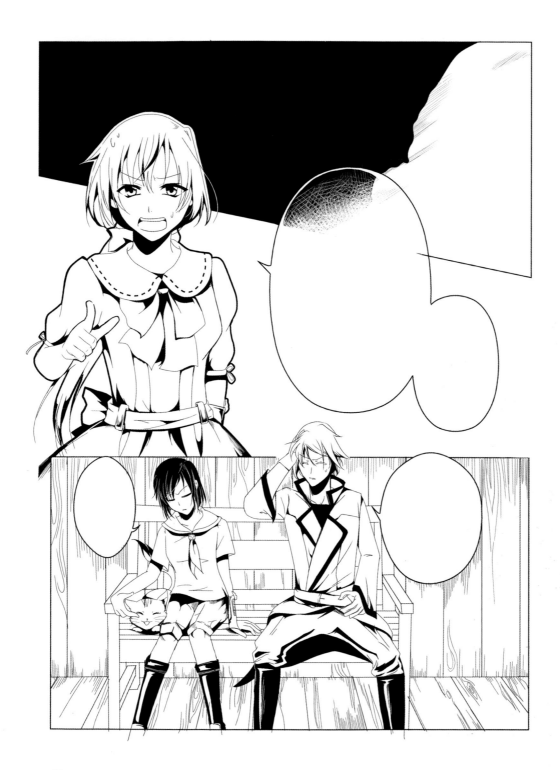

 INKING
Start inking over your pencil sketch or in a separate layer in Manga Studio. Nib pens are most commonly used in manga drawing. In this case, I have used the ink pens in Manga Studio. Practicing will enable you to achieve fine lines and accurate inking regardless of the medium you use.

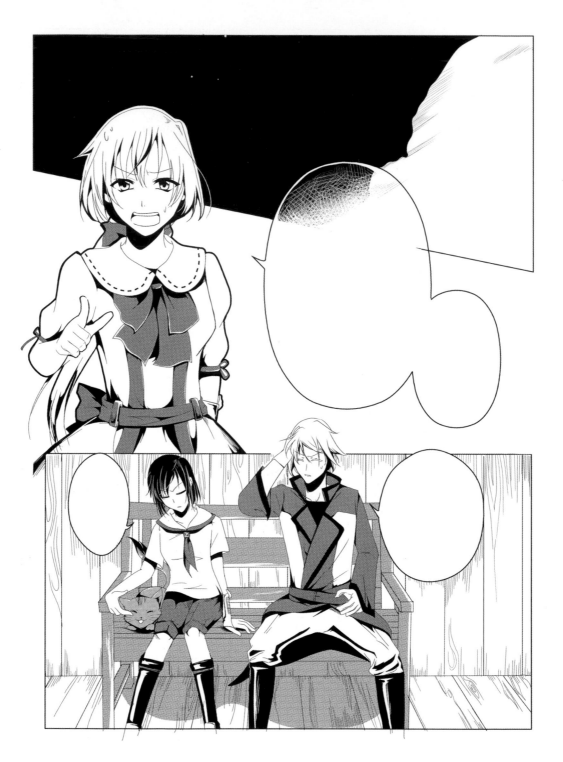

4 TONING

After inking your page, you need to apply tones to enhance the overall look of your page and give it more depth. You may apply tones either traditionally or digitally. If you are short on art supplies, you can scan your inked page, open it in Adobe Photoshop® and apply tones to it. If you have Manga Studio or any other comic art software, you may use the ready-made manga tones they supply. These options are useful and yield beautiful effects.

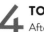

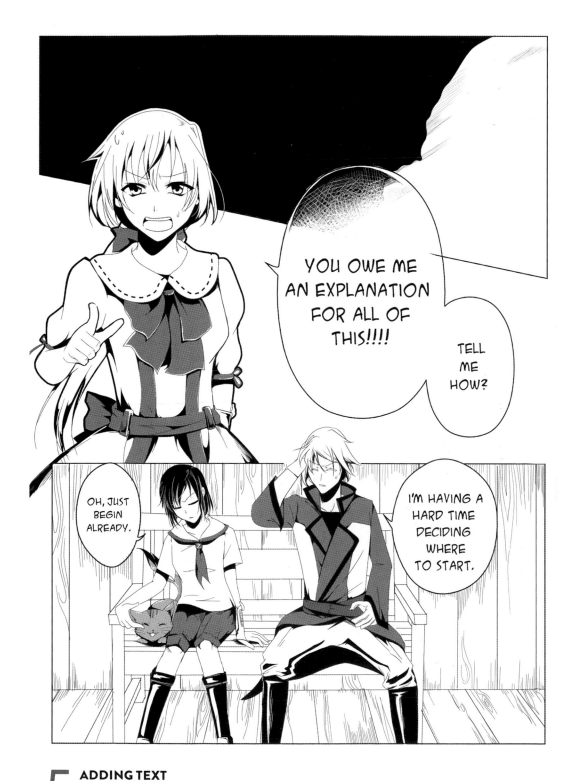

5 ADDING TEXT

You can either use the text tool in Manga Studio or in Adobe Photoshop to easily add text. Use only one font throughout the pages . Go through your text to make sure that it is error-free. You may team up with a writer, or hire an editor to proofread and give you feedback on your story transition and art when you have completed your pages. Once you finish editing, you can move forward and share your manga with the world, either online or in print.

THE OCEAN OF SECRETS

I wrote the first volume of my manga *The Ocean of Secrets* back in July 2009, but I developed and changed many concepts for the series throughout the years. I'm glad that the years of waiting and working did not go to waste; it is not only about enhancing and writing a solid story, but improving your artwork. When I first started, my characters looked immature and I had no style. My art wasn't unique and was full of flaws. Manga is not about drawing girls with big, cute eyes and flawless hair—it is about delivering a story to the reader. If you fail to deliver it before it's fully developed, it will not last for too long.

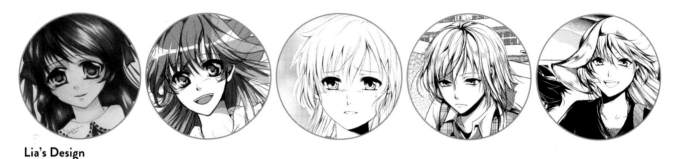

Lia's Design
My character design for Lia changed from 2010 to 2014. You can see that her eyes got smaller, the hair is more defined and she looks more mature than the first design.

I was inspired by the ocean: It is big and beautiful, yet also deep and mysterious. That, in turn, inspired me to unfold secrets about the existence of a different world I imagined. I was inspired by movies and animation series, in general; they have been a source of inspiration since I was a kid. Lastly, I was inspired by my friends and fans. Having so many people support me and my dream fostered a never-ending desire to achieve it.

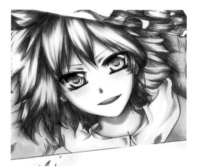

Moria's Design
Moria is brave and kindhearted. It was hard at first to come up with a design to match her personality.

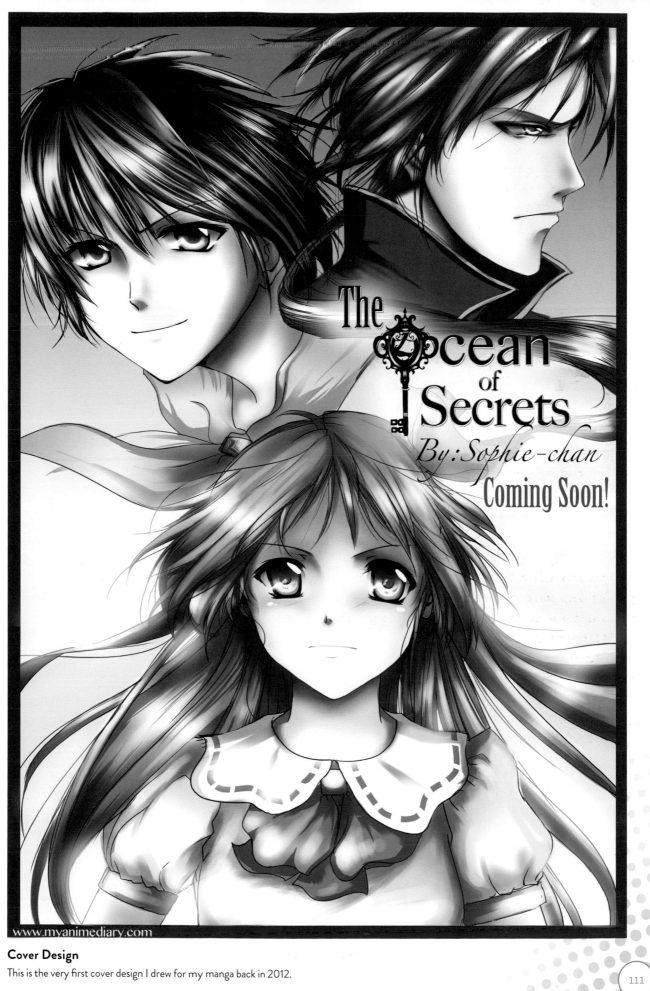

The Ocean of Secrets

By: Sophie-chan

Coming Soon!

Cover Design

This is the very first cover design I drew for my manga back in 2012.

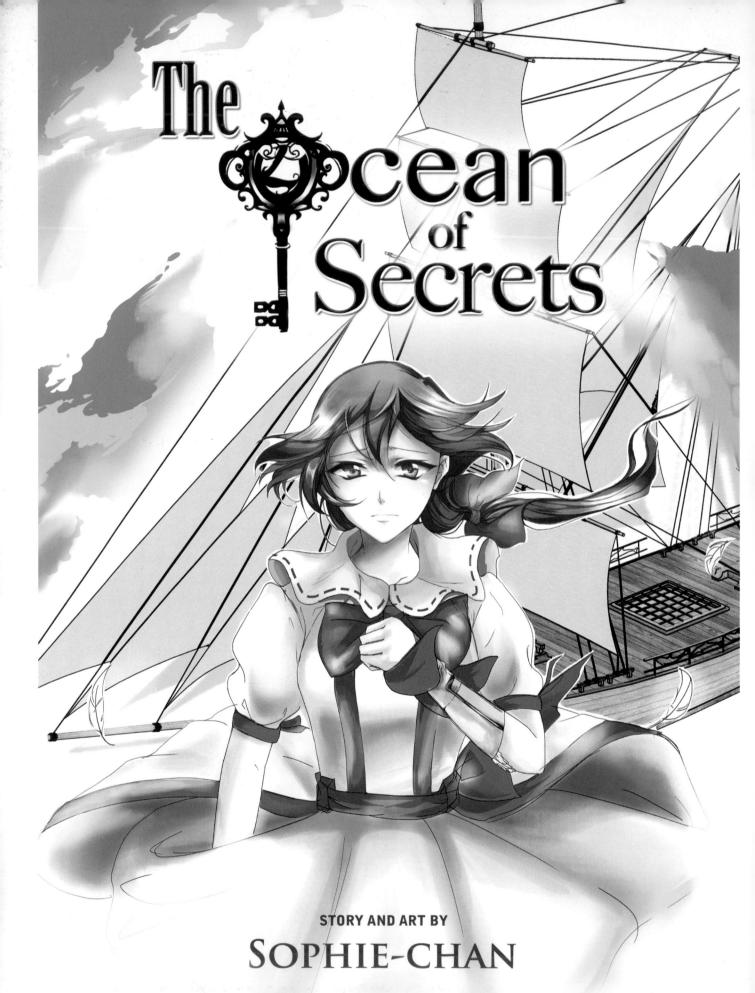

The Ocean of Secrets

of

STORY AND ART BY

SOPHIE-CHAN

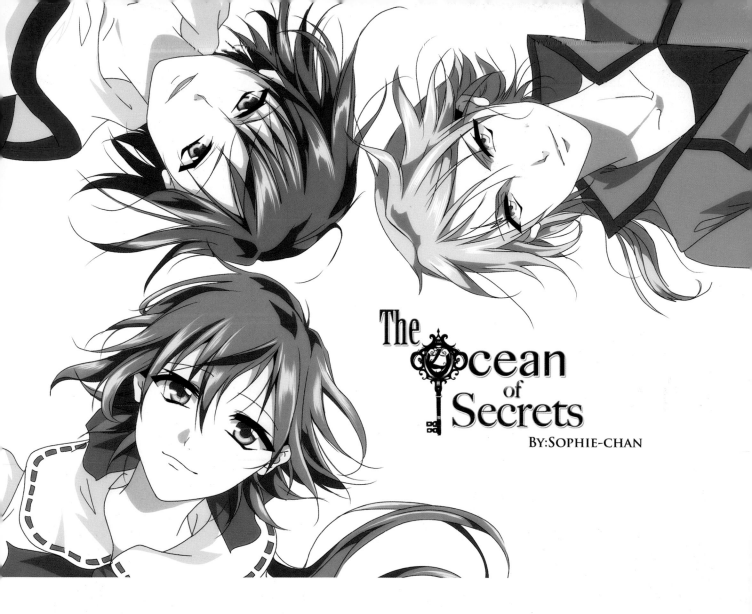

The
Ocean
of
Secrets

By:Sophie-chan

The first manga cover I made had all three characters, which I believe is too much for a cover in an on-going series. Albert's hair color was brown instead of gray, Moria's hair was shorter and Lia looked younger because I had different character profiles for each. In this new cover, Lia is the center of attention. The story revolves around her in volume one. Each volume cover will feature a character. The story is planned to be five volumes, and each volume will feature a new character that will join my story.

How to Draw Lia

In this demo, you will learn how to draw my main manga character, Lia. Lia is a 17-year old orphan who was adopted by a family with a tragic history. She is shy and introverted, which makes it hard for her to get along with her family and friends. Lia is smart, kind and is willing to sacrifice her life for the people she cares about.

1 SKETCH THE FIGURE

Start by drawing a head circle and then sketch the chin and neck as shown. Draw two horizontal lines for the eye guidelines and one vertical line to establish the symmetry of the face. Sketch the ears within the eye horizontal lines, allowing the earlobes to extend a bit down from the lower line.

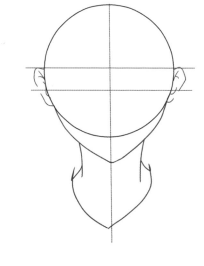

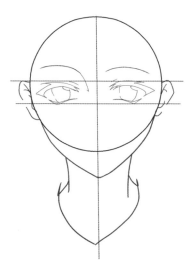

2 DRAW THE EYES

Roughly draw Lia's eyes and eyebrows as shown, following the guidelines. Make sure the eyes fall within the two horizontal lines.

3 DRAW THE FACE AND DRESS

Draw Lia's nose and mouth. You can also sketch the dress and collar. Notice the way the collar is drawn and how the tie fits in beneath it.

4 DRAW THE HAIR

Start sketching the hair, following Lia's hairstyle as shown. Notice how I went beyond the circular head guideline. Lia's hair has very smooth strands.

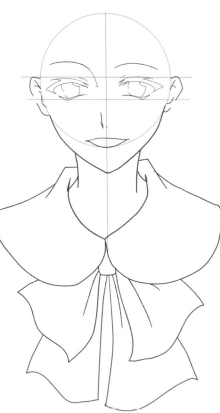

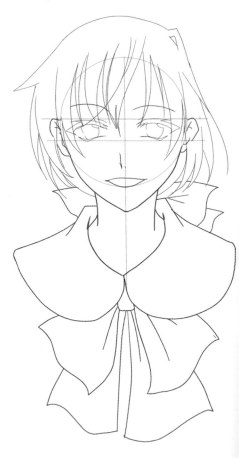

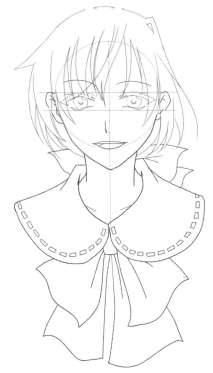

5 ADD DETAILS

Draw her eyes' pupils and add details to the dress. You have finished your sketch! Now you can erase the guidelines and ink the drawing.

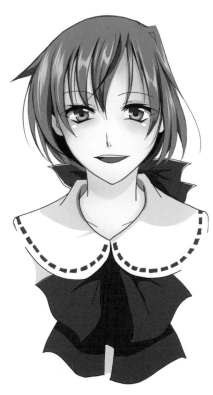

6 ADD COLOR

Let the ink lines dry then start coloring. Since Lia's dress is white and red, you don't need a lot of color to complete it. I used Manga Studio to add color.

Visit **impact-books.com/manga-workshop-characters** to download free bonus materials.

115

How to Draw Moria

This demo will show how to draw my character Moria. Moria is an 18-year old girl who has spent most of her life sailing with her brother, Albert. She is always studying the ocean to discover new fish species. Moria is self-reliant, quick witted and brave.

1 SKETCH THE FIGURE

Start by drawing a head circle, then sketch the chin and neck.

Draw two horizontal lines for the eye guidelines, and one vertical (symmetry) line that cuts the face in half. Sketch the ears as shown. (Notice that her earlobes end on the lower eye line, unlike Lia's.)

2 DRAW THE EYES

Draw Moria's eyes and the eyebrows. Her eyes are smaller and sharper than Lia's eyes. Notice the shape of her eyebrows. Eyebrows can tell a lot about a character.

3 DRAW THE FACE AND SHIRT

Add the nose and mouth. Then draw Moria's shirt. It's a good idea to sketch the shoulder shape first, then draw how the collar fits over it.

4 DRAW THE HAIR

Draw Moria's hair. Make the hair strands as smooth as possible. Then add details to her clothes. Notice how the hair seems to be moving and be windswept because the strands are far apart.

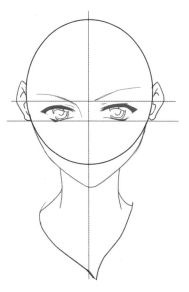
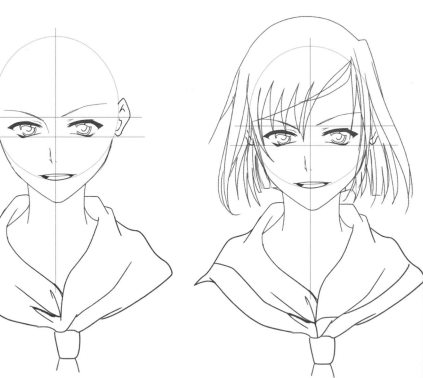

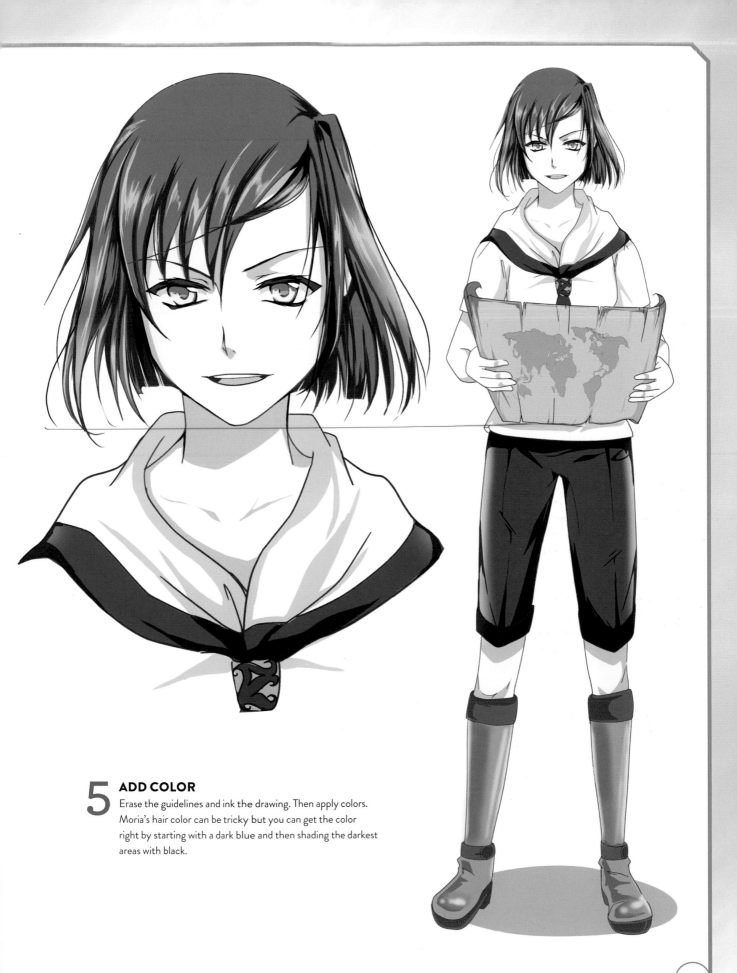

5 ADD COLOR

Erase the guidelines and ink the drawing. Then apply colors. Moria's hair color can be tricky but you can get the color right by starting with a dark blue and then shading the darkest areas with black.

Visit **impact-books.com/manga-workshop-characters** to download free bonus materials.

117

How to Draw Albert

My third character's name is Albert. Albert is Moria's big brother. He's 26-years old. He ran away from his homeland long ago with Moria, as he was accused of murdering the queen of their kingdom. Albert is kind but arrogant sometimes.

1 SKETCH THE FIGURE

Start with a head circle, and sketch the chin and neck as shown.

Draw two horizontal lines (closely spaced) for the eye guidelines, and draw a vertical line that divides the face in half. Add the ears, extending them slightly above and below the eye guides. (Albert's eyes are very small.)

2 DRAW THE EYES

Start sketching Albert's eyes in the guidelines. Notice the edgy eye shape and eyebrows that Albert has. Extend a line from the right eyebrow. This line will better define the nose.

3 DRAW THE FACE AND SHIRT

Draw the nose and mouth. Then sketch Albert's shirt. Notice how the nose is edgy and begin below the line you drew by the right eyebrow. The lower lip is also more defined to give a more masculine look.

4 DRAW THE HAIR

Draw the first portion of the hair. Albert's front hair is always messy. Draw the eye circles as shown. Notice how the pupil doesn't extend to the lower eyelash line, which helps show a more mature look.

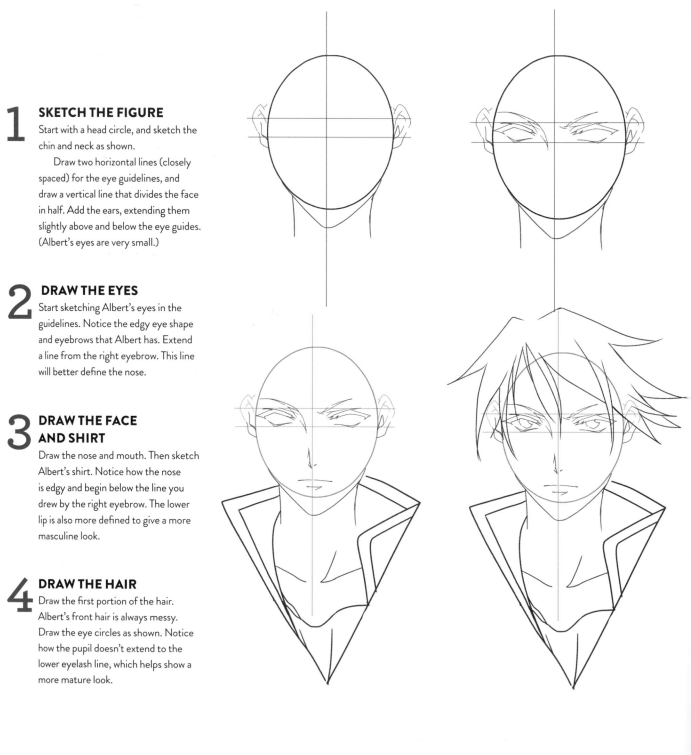

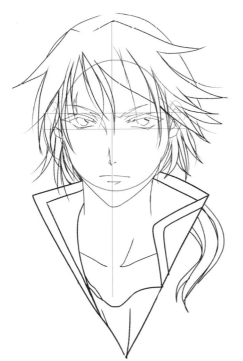

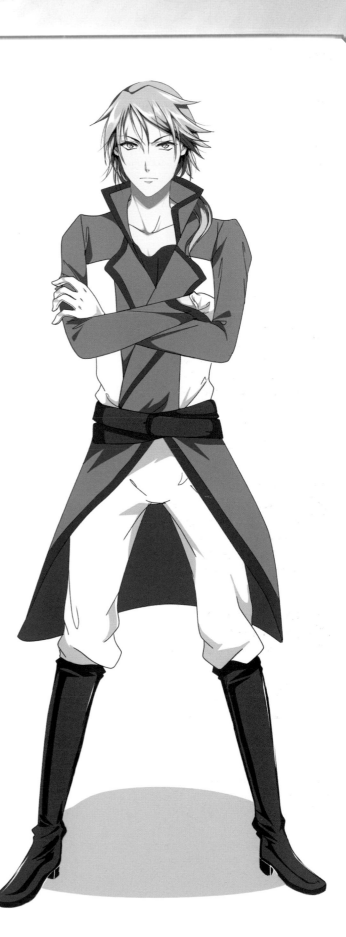

5 FINAL DETAILS

Draw the back part of Albert's hair. Add a lot of strands to make it messy and to give it more volume. Finish up the ponytail then draw Albert's scar on his right eyebrow.

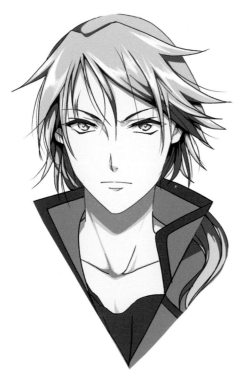

6 ADD COLOR

Erase the guidelines, ink the drawing and add color. Make sure to use different shades of gray in his hair for added dimension.

Visit **impact-books.com/manga-workshop-characters** to download free bonus materials.

119

How to Draw Meme

You might have to draw animals while writing your manga story. In this demo, I'll take you through the steps to draw the cat in my manga named "Meme." I wasn't sure about having a pet in my manga at first, but it's another mystery added since this is not an ordinary cat. Meme's abilities will be uncovered later in my story.

1 DRAW GUIDELINES
Draw two equal circles as shown. This will be you 1:2 aspect ratio, which is the cat size. Cut the circles in half with a vertical line (symmetry line). Draw two horizontal lines that will act as your guideline when drawing the cat eyes.

2 SKETCH MEME'S FACE
Start by drawing the shape of the eyes in the horizontal guidelines. Then draw the nose and the mouth below as shown. Sketch the two ears.

3 OUTLINE THE HEAD
Draw the fur on the cat's cheeks, then draw the rounded chin as shown. Notice how the head is smaller than the initial circle drawn for the sketch.

4 DEFINE THE DETAILS
Draw two half circles, which will be the pupil of Meme's eyes.

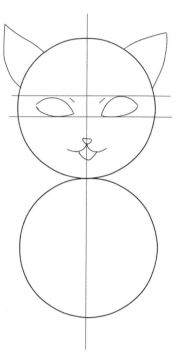

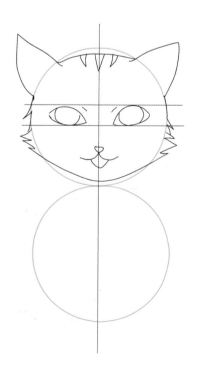

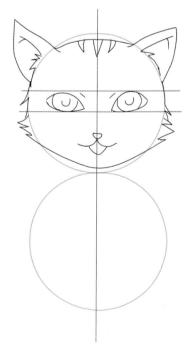

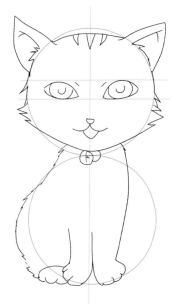

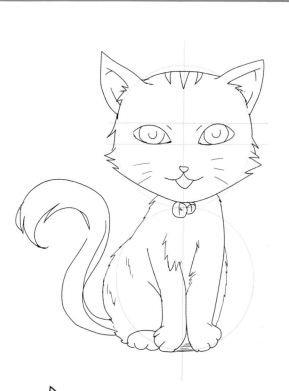

5 SKETCH THE BODY

We are drawing a standing pose, so start by drawing the cat's front legs first, while the other back legs are resting. Create the fur texture on the body by drawing jagged lines along the back.

6 DRAW THE TAIL

Sketch the tail; Meme's tail is longer than an average cat's tail. I like to make it wavy to give it a unique style.

7 ERASE GUIDELINES AND ADD COLOR

Once you are done with the sketch, erase the guidelines. Start inking and add Meme's colors. Meme's eyes are bright blue. You can use Copic markers to give the gradation effect in the eyes or use the gradation tool in Manga Studio.

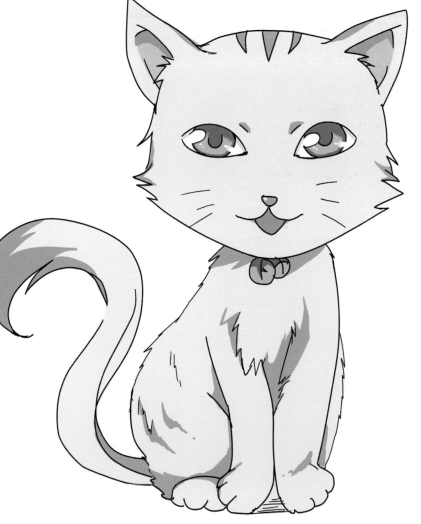

Visit **impact-books.com/manga-workshop-characters** to download free bonus materials.

121

LESSONS LEARNED AND SOME ADVICE

1) Don't print too many books!
If this is your first print run you don't know what to expect. The book quality may not be as good as you imagined. It is safer to start with a couple hundred copies, then move to thousands later.

2) Keep looking for publishers!
Another reason you shouldn't print too many books is that you might be better off leaving the headache of publishing to publishers. Publishing yourself requires a lot of time and money. First you'll need to learn about this industry, which will minimize your focus on the content of your book and reflect negatively upon your career.

3) Read, and never stop reading.
Even if half of what you read is just for fun or doesn't specifically apply to your art, you can still gain a lot of knowledge that will help you grow as a self-published artist.

4) Avoid online addiction.
Don't get swamped in the world of social media. Interacting with fans is cool, and it raises your popularity, but remember that your time is limited. If you are running your own business then time is money.

5) Stay updated!
Learn what's happening in your industry. Maybe in few years time, manga will be more common as an e-book instead of an actual book. Be open to new ideas and experiment with new tools to attract more readers.

6) Things happen for a reason.
School, college and work may have nothing to do with art/writing, but it made you the person you are today. The experience you have gained from such stressful situations reshapes the way you think, behave and write. Enjoy those experiences and learn from them.

I'm glad I've taken every challenge as a learning experience and was able to see that throughout the past ten years, my passion for drawing and writing didn't change at all.

CONCLUSION

I hope this book is a help to you. I tried to make it as simple as possible. Drawing manga is a skill you acquire with practice and time, and that requires passion and dedication. It can be hard convincing your family and friends that you want to become a manga artist; it is even hard to convince yourself that you can do it. You must believe in yourself. Don't ever give up on your goals. Prove to the world that regardless of your race, culture or environment, you can achieve whatever you set your mind to. I'm saying this to you because I have been let down many times. These challenges only help to bring out your strengths and should inspire you to keep going! My advice to you is to follow your dreams. Even if your studies lead you elsewhere, or if you find yourself sitting behind an office desk, that should never be the end of your dreams.

I appreciate your support and wish you the best on your journey!

Sophie

INDEX

Visit **impact-books.com/manga-workshop-characters** to download free bonus materials.

125

METRIC CONVERSION CHART

To convert	to	multiply by
Inches	Centimeters	2.54
Centimeters	Inches	0.4
Feet	Centimeters	30.5
Centimeters	Feet	0.03
Yards	Meters	0.9
Meters	Yards	1.1

fw
a content + ecommerce company

Other fine IMPACT Books are available from your favorite bookstore, art supply store or online supplier. Visit our website at fwcommunity.com.

19 18 17 16 15 5 4 3 2 1

DISTRIBUTED IN CANADA BY FRASER DIRECT
100 Armstrong Avenue
Georgetown, ON, Canada L7G 5S4
Tel: (905) 877-4411

DISTRIBUTED IN THE U.K. AND EUROPE BY F&W MEDIA INTERNATIONAL LTD
Brunel House, Forde Close, Newton Abbot, TQ12 4PU, UK
Tel: (+44) 1626 323200, Fax: (+44) 1626 323319
Email: enquiries@fwmedia.com

DISTRIBUTED IN AUSTRALIA BY CAPRICORN LINK
P.O. Box 704, S. Windsor NSW, 2756 Australia
Tel: (02) 4560-1600; Fax: (02) 4577 5288
Email: books@capricornlink.com.au

ISBN 13: 978-1-4403-4023-9

Edited by Beth Erikson
Designed by Laura Kagemann
Production coordinated by Jennifer Bass

ABOUT THE AUTHOR

Safa Al Ani (Sophie-chan) was born in 1990 in Iraq. She is a self-taught manga artist who gained a following by posting drawing videos on her YouTube channel titled "sophiechan90" with over 23 million video views.

Sophie began drawing and writing stories when she was 7-years old, determined to reach her goals of having her own manga series/anime adaption and becoming well-known worldwide as a manga artist.

With hard-work, patience and determination, Sophie was able to publish her first graphic novel *The Ocean of Secrets*, a full volume manga series, in April 2015.

ACKNOWLEDGMENTS

Sophie owes her success to the immense
support she received from her online fan base,
family and friends, and she wishes to teach and
inspire the next generation of artists.

DEDICATION

This book is dedicated to my fans.